MW00355024

BAY AREA
COCKTAILS

A HISTORY OF CULTURE, COMMUNITY AND CRAFT

SHANNA FARRELL

Photographs by Nando Alvarez-Perez,
Jon Santer and Vaughan Glidden

AMERICAN PALATE

Published by American Palate
A Division of The History Press
Charleston, SC
www.historypress.net

Copyright © 2017 by Shanna Farrell
All rights reserved

First published 2017

Manufactured in the United States

ISBN 9781467137539

Library of Congress Control Number: 2017940918

Notice: The information in this book is true and complete to the best of our knowledge. It is offered without guarantee on the part of the author or The History Press. The author and The History Press disclaim all liability in connection with the use of this book.

All rights reserved. No part of this book may be reproduced or transmitted in any form whatsoever without prior written permission from the publisher except in the case of brief quotations embodied in critical articles and reviews.

This book is dedicated to everyone who has shared their stories with me.

CONTENTS

ACKNOWLEDGEMENTS

T here are countless people who helped to make this book possible. The list is long and humbling. My everlasting gratitude to Ellie and Lance Winters, Thad Vogler and Martin Meeker for their early, and consistent, support of my work. Thanks to my first cohort of narrators, including Vogler, Julio Bermejo, Jörg Rupf, Jennifer Colliau, Claire Sprouse and Rhachel Shaw, as well as supporters Kayoko Akabori and Yoko Kumano of Umami Mart, Celia Sack of Omnivore Books and Deborah Marskey and Juan Carlos Garcia of Shrub & Co., all of whom made this project possible.

Thanks to my photographers, Nando Alvarez-Perez and Jon Santer, for providing me with such beautiful shots, and to Vaughan Glidden for styling the stills so expertly. Much love to Jacqueline and Kevin Dowell of Thirsty Vintage and the 86 Co. as well as Umami Mart, who all generously lent me their glasses and barware for the photos. Thanks to everyone at St. George Spirits, Chris Lane and Ramen Shop, Daniel Parks and Pagan Idol, John Dampeer and Hamlet and Emily Reynolds for providing us with locations to take the photos. Thanks to Phil and Hilary Brodey, who allowed me to use portraits from Capra Press' *Distilled Voice: California Artisans Behind the Spirits*. Tremendous thanks to all those who helped make these photos possible, including Joe and Cathy Fragola, Rachel and Brad White, Robin Nagle, Maggie Hoffman, Evan Schaeffer, Bonnie Ross, Lamar Lovelace, Risa Nye, Melissa Watson, Russell Connacher, Martin Cate, Margaret Day, Amy and Julio Alvarez, Lisa Rubens, Dinah Sanders, Ethan and Andrea Ladd, Barbara and Abe Hardoon, Holly Henry, Dave Freund, Ada Alvarado,

ACKNOWLEDGEMENTS

Edgar Harden, Lou Bustamante, Sara and Eric Marxmiller, Maia Bittner, Nick Melle, Jessica Schreiber, Jessica Miller, Sophie Cooper, Andrea Perkins, Susan Higgins, Sewon Barrera, Chris Cabrera, Vu Pham, Mary Chiles, Jessica Peterson, Adrian Hopkins, Wyatt Howard, Jon Glidden, Lindsay Jones, Jessica Gutierrez, Michelle Walk, Rafael Jimenez Rivera, Douglas Fair, Claire Sprouse, Buzz Anderson, Corina Darold, Justin McGuirk, Nate Stearns, Pearl River Public Library, James Lee, Shannon Supple, Nat Harry, Diana Yee, Genevieve Conaty, Matthew Wyne, Andrew Wooster and all those who donated anonymously.

I am especially grateful to my readers, including Eric Marsh, Carla Fresquez and Cristina Kim. Your help was invaluable.

Thanks to Talia Kleinplatz for letting me pull a guest shift and hone my narratives on *Two for the Bar*.

Thanks to my parents, Jim and Suzanne Farrell, who have allowed me the freedom to pursue my dreams and believe that anything is possible, including a book, and my sister, Jessica Mara, for always being my biggest cheerleader.

The biggest thanks of all belongs to John Fragola. I could not have done this without his unconditional love and support, willingness to let me think out loud and perpetual excitement to hear about my interviews, as if they were his own. This has meant the world to me.

INTRODUCTION

I distinctly remember the first cocktail I ever made. After years of waiting tables, I had finally earned a spot behind the bar. The drink was not your ordinary three-ingredient cocktail. It was a Pisco Sour, a drink that might as well be on the Peruvian flag. The bar was known for this cocktail, as our manager had been featured on a local Brooklyn television station discussing how we made it. I cracked a fresh egg directly into my tins, squeezed half a lime by hand into my jigger and measured a bar spoon of fine white sugar. After I assembled all of the ingredients in my tins, including the pisco, I added ice and shook the shit out of it, as I was expressly instructed. I wasn't yet skilled enough to know that in order to get the fluffiest possible egg white, I should shake first without ice for a few seconds to obtain maximum froth, later adding ice for dilution. Instead, I poured the drink into a coupe glass, added a few dashes of Angostura bitters on top and proudly served it to my guest. I'll never forget the rush of satisfaction making that drink gave me. My guest sipped it and nodded in approval. Instant gratification achieved. I was hooked.

A short time later, I had the best Manhattan of my life. It was stirred and poured over a large square ice cube, garnished expertly with a lemon twist. I had never tasted anything so interesting. The flavor of the whiskey with the fresh sweet vermouth swirled in my glass and on my tongue. I thought about that Manhattan for years to come, always chasing that experience but never quite able to replicate it.

Those two experiences—one making and one tasting—opened the door to a whole new world for me. These moments of accomplishment and inspiration allowed me to progress at a stagnating restaurant job, where I was working my way through graduate school. Like many nascent to the world of cocktails, this new avenue of exploration challenged me to do more and be more. It validated the process-oriented approach I took to most things. At the time, I was living in Brooklyn and had been raised by proud New Yorkers. Like countless others, I thought that New York was the center of the world, including cocktail culture. That is, until I moved to California.

I relocated to the Bay Area for my dream job as an oral historian with University of California–Berkeley's Oral History Center. Having worked in restaurants and bars throughout my twenties, I found comfort on a bar stool when I first moved to town. Though I was no longer shaking and stirring for guests, I was most interested in talking to those who were. Here, in my new home, I found my community among bartenders. Less than a year after I started working at the Oral History Center, I launched an oral history project on West Coast cocktails. I assembled an advisory team that included famed industry veteran Dale DeGroff and the venerable cocktail historian David Wondrich. After having several conversations with them about the project, I quickly dove into the history of cocktail culture in the West. And boy, did I have a lot to learn.

The legacy of bars on the West Coast is deep and diverse. San Francisco has always been a cocktail town, which is a fact that was repeated over and over to me in my interviews. Many popular national trends would not exist without the contributions from bartenders in the Bay Area. San Francisco was one of three global cities that helped shape cocktail culture as we know it today, equal to New York and London. My interviews with distillers, bar owners, bartenders and cocktail historians illustrated just how important the Bay Area's history with cocktail culture has been for many decades. Its geographic location lends itself to proximity for imports, as San Francisco was once a port city. It benefits from the technology coming out of Silicon Valley. The access to diverse agriculture highlights seasonality and breeds creativity. It provides distillers with interesting ingredients. The size of San Francisco and cities in the East and North Bays engender a small, close, supportive community. The intellectual nature of the area creates an environment where bar menus can incorporate history and consumers are savvy, often curious to try new things. These are just a few of the aspects that make the Bay Area unique.

What follows is the story of the West Coast cocktail, cultivated in the Bay Area. These pages are full of narrative history from those I have interviewed, including bartenders, bar owners, writers and distillers. While some might not find this to be the definitive story, it is my interpretation of the history that I have so carefully researched. It is with great pleasure that I share this book with you.

LAYING THE FOUNDATION

FROM THE INDUSTRIAL REVOLUTION TO CHEZ PANISSE AND THE BIRTH OF CRAFT DISTILLING

Whether you like it or not, alcohol is a staple in American culture. Some of the country's earliest disputes were over taxes related to whiskey.* Meanwhile, soldiers used to get an alcohol ration and bars functioned as the social center of towns. Then Prohibition happened, forever changing America's relationship with booze. Alcohol, bartenders, distillers and bars were villainized. The negative perception of all things spirit-related created a culture that made it hard for professionals to do anything that could be seen as remotely celebratory of booze. For decades, people couldn't get loans from the bank to start a bar, had to jump through legal hoops to start a distillery and were not seen as serious businesspeople if they worked in the spirits industry.

Bartending wasn't a respectable profession but, rather, something you did to pay your bills while you were trying to do something else. Society didn't value it as a legitimate career. When I was bartending my way through graduate school in 2009, I was constantly asked "when I was going to get a big girl job" or treated as if I was intellectually inferior to those whom I was serving. At the same time, restaurants with sub-standard beverage programs were not as highly regarded as those whose drinks matched the

* In fact, the excise tax was originally proposed by President George Washington's secretary of the treasury, , Alexander Hamilton, in 1791. It was meant to create federal income so that the government could pay off the debt incurred by the Revolutionary War. Distillers were unhappy about this mandate, which led to the 1794 Whiskey Rebellion. Washington himself led a militia to squash uprisings of the rebel distillers. This marks the beginning of America's fraught relationship with alcohol and perhaps planted the seeds for Prohibition.

quality of food. Alcohol still serves as an important social lubricant, allowing people to come together over a Daiquiri at a bar, a bottle of wine at dinner or a keg in a neighbor's garage. Wineries are travel destinations, at home and abroad. Bars and distilleries create jobs for people so they can earn an honest income. And many bartenders have their finger on the pulse of their community, providing people, locals or otherwise, with information on things to do or see.

In reality, people in the bar business are some of the most intelligent, savvy, passionate, creative and socially adept people around. They are only now being regarded that way. Many people romanticize running a distillery or bar, though those who do it for a living can attest to how hard they work. Even though most bars and restaurants have razor-thin margins, more and more people are choosing this as a career and are making it work for themselves. It's been a long road to get here, undoing decades of a fraught past. On the West Coast, and in the Bay Area specifically, there has been an immense amount of work to restore the industry's reputation. The region is a leader in both spirit production and bar work. Over the past thirty years, a dedicated, visionary cohort of people have helped change not only the landscape of the bar world but American culture as we know it today.

THIRTEEN YEARS THAT CHANGED THE COURSE OF HISTORY

Navigating the complicated web of drinking laws is a strange, confusing task. In Oregon, which is a control state, bars buy spirits from the same places as regular customers. In New York, distillers can sell their spirits at a farmers' market. In California, distillers can't sell liquor directly to consumers if they produce over a certain amount of booze annually—except if it's brandy, which can be sold directly to consumers at distilleries because it's considered a food-based product. However, breweries and wineries can sell to visitors as often as they want, regardless of where, what or how much they produce. Blame these antiquated laws, as well as a host of other things, on Prohibition. When telling the story of the modern cocktail revival in the Bay Area, Prohibition is a logical place to start because it was distillers who helped kick off the renaissance. They are the people who make the ingredients necessary for a quality cocktail.

The Noble Experiment, America's prohibition of alcohol, lasted for thirteen long, dry years. Those years changed the cultural, political and legal landscape of the country. In many ways, we are still recovering from its impact. On January 17, 1920, the Eighteenth Amendment ushered in Prohibition, making alcohol illegal to make, sell and distribute. This lasted until December 5, 1933. While the ban on alcohol affected the entire country, it had a unique impact on the Bay Area. Leading up to Prohibition, San Francisco was a booming port city. Booze came through its ports and enabled the success of bars in the area, especially those close to the waterfront. San Francisco's Columbus Avenue was flush with drinking establishments. Out of the North Beach neighborhood came the "Devil's Acre," a portion of Columbus Avenue notorious for its excess of saloons and prostitution. San Francisco became a place where a few bartenders, made famous by history, were able to shine. Two such bartenders, Jerry Thomas and Harry Johnson, came through town and later published two of the earliest cocktail books. William "Wild Bill" Boothby tended bar at the Palace Hotel while Duncan Nicols made the Pisco Punch famous at his bar, the Bank Exchange. Across the bay, there are many theories that the Martini was created in Martinez. The Bay Area was on the cocktail map long before there was a map.

When Prohibition hit, it ushered in a sobering reality. Many businesses were either forced to close or went underground as a result of the Eighteenth Amendment. Thus began the interruption of bartenders' professional lives and dignity for their career choices. The legacy of the barkeeps who made

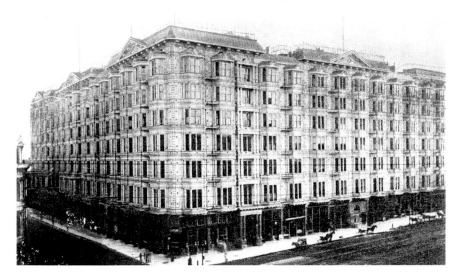

Palace Hotel, San Francisco. *Courtesy of the Bain Collection, Library of Congress.*

15

the city shine was no longer allowed to flourish. Those who wanted to stay in the industry went to Europe, where they could continue to grow their skills (and be respected), or kept a low profile at speakeasies. Since spirits could no longer legally be produced or sold, people began making their own. Many who tried their hand at this were amateurs, and the quality of available alcohol sharply declined. Fruit, juice and sweeteners were integrated into cocktails to mask the inferior taste of booze.[*]

Bars weren't the only aspect of the spirits industry that was affected. Distilleries took a big hit and were shut down all over the country. It's hard to know exactly how many distilleries closed in California because there aren't many records, but suffice to say most went out of business. Many wineries, distilleries and bottle shops were forced to close their doors. In Northern California, where winemaking was an established industry, some wineries were able to strike deals with local churches that were exempt from Prohibition because wine was a traditional part of Catholic services. Distilleries in Northern California weren't lucky enough to be eligible for that loophole. In the long run, this exemption gave wineries a lasting advantage over distilleries. Because their wine production went uninterrupted, they were able to strengthen their reputation during the Noble Experiment. This allowed them to enjoy strong legal lobbying power once production was permitted again in 1933 when Prohibition ended.

Then came a number of legal challenges for California. Prior to 1920, all things alcohol were regulated by the federal government. In 1933, when the Twenty-First Amendment passed—effectively repealing the Eighteenth Amendment (and making alcohol legal again)—the regulation of alcohol fell onto individual states. In an attempt to have a set of checks and balances, the three-tier system was created. Some form of it exists in every state. It requires producers to sell their products only to distributors, who then sell to retailers. Single ownership crossing all three tiers became illegal, something that is still strictly enforced today. The idea behind this system was that it would curb excess and abuse from any one tier and make it possible for taxes to be levied at various transfer points (meaning that taxes are imposed when distributors buy from distillers, again when a retailer buys from a distributor and a third time when a consumer buys from a retail store).

The three-tier system has been in place since 1933, but it wasn't until the past couple of decades that it was challenged. In order to create a

[*] For this reason, many people often split classic cocktails into two categories: pre-Prohibition and Prohibition era.

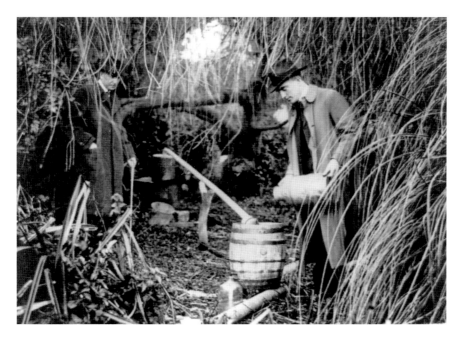

Dismantling a still in San Francisco. *Courtesy of the Library of Congress.*

business-friendly environment, many states have created exceptions to the system under different agricultural acts. In California, where wine dominates, both wineries and breweries have always been allowed to sell directly to consumers, bypassing the second tier. The same was not true for distilleries in California until 2015; strict interpretations of the system remained in place for eighty-two years.* It wasn't even until January 1, 2014, that distilleries could pour tastes for visitors. Assembly Bill 933, which a dedicated group of distillers fought hard to get passed, was a huge step forward in helping California to catch up to the majority of other states in the United States. It also paved the way for Assembly Bill 1233, which was enacted in 2016. The bill allows distillers to sell up to three bottles per person per day if the production is under a certain level.

It's been much harder for distilleries to get on equal footing as wineries and breweries because of the historic villainization of hard alcohol, ingrained deep into the structure of legalities surrounding making and selling it. But as the public's interest in spirits has grown, the demand for friendlier laws has put pressure on the legal structure to change. Now, spirit production is booming in California. More distilleries are opening each month. This recent

* Hence, the significance of lobbying power.

upsurge in distilleries is due in large part to a few very special Europeans who came to Northern California and fell in love with the culture, the people, the food and the agriculture. All three, independently of one another, opened distilleries that would come to define the Bay Area as a leader in the craft cocktail revival.

FROM THE INDUSTRIAL REVOLUTION
TO CHEZ PANISSE

In order to understand why three young Europeans—Jörg Rupf, Hubert Germain-Robin and Miles Karakasevic—all chose to make the Bay Area their home, we must understand what was happening in parallel industries. The public's interest in cocktails started to decline after Prohibition, but the thirteen-year dry period wasn't the only thing that killed their popularity. It was in part due to the Industrial Revolution, which led to the "culinary dark ages." As many new technologies are born out of wars and effectively change the world we know, World War II was no exception. It gave us things like penicillin, pressurized airplane cabins and the first computer. It also changed the way in which the world eats. During the war, there was a national food shortage, and rationing was implemented. Canning food, which was traditionally done at home in small quantities to preserve seasonal crops, became mass scale. Canneries exploded, employing thousands of people, and preserved, processed food became a staple in the American diet. Foods including SPAM, Cheerios and M&Ms were introduced, among many others. After World War II, microwaves became a household item, leading to pre-packaged reheatable food, known as TV dinners. These foods were quick and easy and soon became normalized. Food was a source of fuel, not flavor. This era became known as the "culinary dark ages," and the recovery period was long. There was a lack of connection between food and agriculture, and people favored pre-made meals that were always available in boxes and cans at the store. Many, enchanted by these innovations, didn't question this system, and it soon became a part of American culture.

But a sea change started in the 1970s. Alice Waters is the woman responsible. Waters, a thoughtful and soft-spoken woman, was a New Jersey native whose family moved to Van Nuys, California, in 1962. She was greatly affected by the political unrest that plagued the 1960s. In fact, her

political consciousness led her to Berkeley, California, after she decided to trade the traditionalism she experienced at UC–Santa Barbara for the politically engaged student movement at UC-Berkeley. She was part of the Free Speech Movement that swept through campus and later became involved with local politics when she worked on Robert Scheer's congressional campaign. Although Scheer was unsuccessful in his bid for a seat in Congress, it gave Waters the gumption she needed to start a revolution.

At age nineteen, Waters spent a year in France, where she fell in love with the culture of food. What she experienced was nothing like the United States, where the influence of the Industrial Revolution was strong. Farmers' markets were everywhere

Freshly cracked egg. *Photo by Nando Alvarez-Perez and Vaughan Glidden.*

in France. "People wouldn't think of having food several days old," she told Dean Riddle in a 1998 interview for Waitrose.com. "There was a kind of life to everything I ate, a kind of beauty about it. I just had never experienced those tastes." Consequently, she spent a lot of time in French kitchens. She took her newfound love for cooking with her when she returned to Berkeley.

Cooking and entertaining became the foundation of her life. After several years of continuous dinner parties where she would cook through French recipes, she decided to open her own restaurant. She opened Chez Panisse in 1971 with a $10,000 loan from her father. At a time when most Americans still preferred the ease of TV dinners and canned ingredients, Waters modeled Chez Panisse after the farmers' market culture she experienced in France. Waters challenged the idea that French food was heavy and sauce-laden. She made her dishes simple, allowing the freshness of the ingredients to shine. That meant that while she used French techniques, she didn't drown the dishes in sauce.

Though it took a few years for Chez Panisse to catch on and turn a profit—ingredients were expensive, preparation of them was labor-intensive and Waters didn't want to charge her patrons too much—the restaurant began to garner attention. Celebrities came in, and critics gave it favorable reviews. This deepened Waters' conviction for using the best possible products. Chez

Panisse continues to use locally sourced food from people who care about their crops and the future of their land.

The significance of Chez Panisse cannot be underestimated, especially in the Bay Area. Not only did Chez Panisse help the United States climb out of the "culinary dark ages," but it also allowed eating to become a political act. "When you eat together, and eat a meal you cook yourselves, such meals honor the materials from which they are made; they honor the art by which they are done; they honor the people who make them, and those who share them. I believe that food is a medium for us all to do more meaningful work in our own lives. And, more than that, I believe we have an ethical obligation to do this work, for the sake of humanity—better lives for each other and for the generations who come after us," she said in the Riddle interview. Waters' desire to create a place where quality drives a restaurant's mission may seem commonplace now, but it was revolutionary in the 1970s and 1980s. It inspired many to see how delicious a simple dish with fresh, local ingredients could be and to incorporate those principles into daily life. Many chefs who have worked with Waters have gone on to open their own places, and consequently, her philosophy has spread all over the world.

Waters' influence goes beyond just chefs. Her political approach creates a culture that can be adapted to any aspect of agriculture. The bar community, particularly in the Bay Area, has taken many cues from her philosophy and made her viewpoint its own. The start of the cocktail revival was largely inspired by her work.

THE THREE EUROPEANS AND THE BIRTH OF CRAFT DISTILLING

Alice Waters created an environment where European techniques were respected and attention to quality of ingredients was valued. Her work made space for three visionary Europeans to carve out a niche of their own. These men—Jörg Rupf, a German; Hubert Germain-Robin, a Frenchman; and Yugoslavian Miles Karakasevic—all made their way to the Bay Area in the 1970s and opened their respective distilleries in the early 1980s. Their appreciation for the area's agricultural richness coupled with their proximity to people who shared their value of using local, seasonal and unmanipulated crops enabled their success in the Bay Area. All three started with specialized distilleries, and their ability to succeed was a precursor to the modern cocktail

Right: Aging spirits. Photo by Nando Alvarez-Perez and Vaughan Glidden. *Courtesy of St. George Spirits*.

Below: Jörg Rupf of St. George Spirits with his still. *Courtesy of St. George Spirits*.

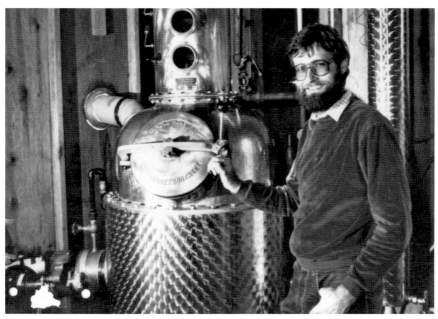

renaissance. This connection—with distillers at the forefront—illustrates the necessity of a strong relationship between producers and bartenders, much like the practices of Waters with her chefs and purveyors. Each distiller impacted the industry in unique ways. They opened the door to barroom creativity and allowed a dormant interest in cocktails to be reignited.

In the early 1980s, a tall, slender, jovial man started the first distillery in California since Prohibition. Jörg Rupf founded St. George Spirits in 1982. Its first iteration began as a shack in Emeryville, California. "It was easier to establish in the town of Emeryville, which at the time was a rundown industrial place with a lot of obsolete buildings," Rupf says. "You wouldn't know this now, but then that was the truth." But before Rupf started his operation in Emeryville, he already had experiences well beyond his thirty-eight years.

He was born in May 1944 in Colmar, an Alsatian region that runs along the border of Germany.* His family owned a brewery, like many families in Europe. He lived through World War II as a child. Part of his house and the family's brewery were destroyed by airstrikes. His family fled to the Black Forest (in Germany) and then later moved to Lake Constance, where Rupf was educated. In college, he pursued a career in law and became Germany's youngest federal court judge at just twenty-eight years old. He worked as a judge for a few years before transferring to the Ministry of Culture. This move enabled him to do a post-doctorate in 1978 at the University of California–Berkeley to study art and the law. Rupf was immediately drawn to life in the Bay Area, as he felt more freedom to engage in meaningful work. This empowered him to resign from the Ministry of Culture in 1979 and pursue distilling full time. The Bay Area became his home.

Rupf started test distilling in 1980, shortly after the oil crisis in 1979 ended. He had made eau de vie, a fruit-based brandy, at his family's brewery growing up, so he began with what he knew. He used all kinds of fruit to make his early brandies. He sourced ingredients locally, like Alice Waters. "In the beginning," Rupf says, "I got pears from Lake County. I found that the Mendocino pears in some areas are even better." He received high praise from the likes of Julia Child, with whom he exchanged a letter after he sent her three bottles. She wrote, "I think the framboise couldn't be better, and the Marc tastes like real Marc, plus a little extra something which must be those Gewurztraminer grapes." Chez Panisse also stocked his products.

* In fact, Colmar was part of Germany from 1871 to 1918 and again from 1940 to 1945, during the latter of which Rupf was born. It became part of France permanently in 1945.

Rupf used his knowledge of the law to make the distillery a legal operation. This is what brought him to Emeryville. "It was known that Emeryville was a good, easygoing community where you could get stuff done that you couldn't get done, for instance, in Berkeley," he says. "Nobody paid much attention to anything. There was a small winery on Stanford Avenue in an old Shell research lab called Veedercrest Vineyards. I was running my application under their auspices, which made it a little better because it only took me a year and a half to get my license. I went to the city hall and said, 'Here's the winery building and I want a permit for a storage shed.'" He was approved after paying a fifteen-dollar fee. "I was the first one to do this. The city had no idea how to deal with me," he recalls. He was told the city building inspector had to approve his facility. "So I built my own shack in the back of this ramshackle building. It was just this wooden thing." He got the distillery online and named it St. George Spirits. It was named partially for his hometown, Freiburg's, patron saint (as well as the British spirits industry) and partially after a nickname he had earned. By the early 1980s, he started going by "George" because no one could pronounce his name. One night, at Spenger's restaurant in Berkeley, he wrote down his name as George on the wait list. He was told that they already had a few other Georges on the list and that he also looked like a saint because of his long beard. "I said, 'Okay, put me down as St. George,'" Rupf recalls. Thus, St. George Spirits was born.

Jörg Rupf of St. George Spirits.
Courtesy of St. George Spirits.

In the early days, he worked hard to find a distributor and earn credibility from his European counterparts. Americans weren't familiar with eau de vie—they knew it as schnapps, something that was artificially flavored and relatively unpopular—so the majority of his business was export. While Rupf worked to secure an international distributor, his second in command and first hire, Bill Mannshardt, oversaw all the operations. Mannshardt joined the distillery in 1984 and stayed for twelve years. He kept up the equipment, facility and administrative paperwork and learned to distill from Rupf. While production was still manageable for two people, Rupf and Mannshardt manned the stills. Mannshardt was very important to St. George's early success.

Shortly after, two others opened facilities just north of San Francisco. Like Rupf, they made brandy because it was exempt from California's normal spirit laws. (It was treated as food because it came from fruit and could be sold directly to consumers, like wine.) One of these men was Hubert Germain-Robin, who opened his distillery in Ukiah, California, in 1983. Germain-Robin, a slight, bearded man, grew up near Cognac, France, in a family of distillers. In fact, his family started distilling in 1782 under the name Jules Robin & Company. Throughout his childhood, Germain-Robin worked in his family's vineyards, wine cellars and on their bottling line, arming him with practical knowledge he would later use in his own production. To expand his skill set, he took courses on distillation at the Foundation Fougerat in Cognac. He studied viticulture and vinification and learned traditional techniques of double distillation on manual equipment, giving him comprehensive practice with the nuances of spirit production.

Germain-Robin traveled extensively before settling in Northern California, working at a few different distilleries along the way. On his travels in the early 1980s, he picked apples in Canada with his wife to earn money. Soon after, they hitchhiked to California. Fortuitously, they were picked up in Ukiah by Ansley Coale, a UC-Berkeley professor turned rancher. They worked on Coale's farm while they were in the area. They became fast friends, and their conversations laid the foundation for what would later become a business partnership.

Hubert Germain-Robin. *Photo by Hilary Brodery. Courtesy of CAPRA Press.*

Before fully committing to America, Germain-Robin continued his travels in Mexico and South America and back to France for a short while. In 1982, he returned to California, this time for good. He and Coale had stayed in touch. He went back to Coale's Ukiah ranch, this time with an alambic still and a few oak barrels.

The two started to distill brandy. They named the distillery after Germain-Robin. After having worked for many others, Germain-Robin found it satisfying to have control over the distillation process. He used grape varietals grown locally, and his brandy found support from the Mendocino wine community. It became a favorite of Ronald Reagan's and was served at Bill Clinton's presidential inauguration ball. Germain-Robin remains a high-end product that can be found in bars, restaurants and bottle shops all over the Bay Area.

The third distiller who got started in the 1980s was Miles Karakasevic. Karakasevic, a tall man with a bushy mustache, also came from a long line of distillers—he was the twelfth generation. His family made wine and brandy in Yugoslavia. In a profile for the book *Distilled Voices*, he says that the spirits he makes at his distillery, Charbay, are the "result of a long heritage of classical apprenticeship and university training."

He grew up distilling with his family before founding Charbay in 1983. He earned a degree in enology and viticulture from the University of Belgrade in 1960. Like Germain-Robin, Karakasevic traveled around Europe and Canada. He moved to the United States in 1968 for an enology job, landing in Madera, California. He spent some time at the University of Michigan, but his family grew tired of the weather, so they eventually returned to California.

Back in Northern California, Karakasevic found that although the wine industry had a big presence in the 1970s, it was the large companies that were producing the vast majority of wine coming out of Napa Valley. It wasn't until the early 1980s that wineries there began to proliferate, growing from 330 producers in 1975 to 508 by 1980.

After working for others for years, he decided to strike out on his own in 1983. He started his distillery as Pruhlo Alambic Still Company, also known as Domaine Karakash, where he, too, made brandy. He sold wine and grapes to restaurants and liquor stores in San Francisco before ramping up production in 1986.

In 1991, Karakasevic changed the company name to Charbay—a combination of the words "chardonnay" and "brandy"—and brought his son, Marko, a towering, dark-haired man, on board. Karakasevic credits

Marko, the thirteenth-generation distiller in the family, with taking the initiative to expand their portfolio and grow the company. In the 1990s, vodka was dominating the global spirits market. Many were flavored with artificial ingredients. The Karakasevics decided to own this trend. In 1996, they began making flavored vodkas from fresh fruit. A few years later, in 1999, they released their first whiskey. Marko developed an interest in tequila and struck up a friendship with Carlos Camarena of Tapatio, a tequila distiller based in Arandas, Mexico. Charbay released a tequila with Tapatio in 2009 (a spirit important to the Bay Area's cocktail renaissance, as we'll see). Marko would also develop good relationships with local bartenders, an asset to both Charbay and the bar community because information and ideas could be freely exchanged.

Back in the East Bay, as Germain-Robin and Charbay were growing, Rupf made two important moves: he hired Lance Winters, a bright, witty man with an immense amount of integrity, in 1996, and he began training new distillers all over the country. Winters, who would later become Rupf's partner in St. George Spirits and eventually owner in 2010, had been a beer brewer and a home whiskey distiller. He had read about St. George in *Sunset Magazine* and immediately knew that he wanted to be part of the company. "Whoever had written the article was waxing poetic about how

Three generations of Charbay's Karakasevics. *Photo by Hilary Brodery. Courtesy of CAPRA Press.*

beautiful the aromas of the eau de vie was. Nobody was really talking about anything except for scotch at that time, and I thought, 'I must meet the man who makes this,'" Winters says. Winters showed up to the distillery, unannounced, and was met by Bill Mannshardt, who told him that Rupf wasn't in. Persistent, Winters came back. He finally met Rupf on his third trip to the distillery.

Whiskey ingredients. *Photo by Nando Alvarez-Perez and Vaughan Glidden. Courtesy of St. George Spirits.*

Rupf remembers that day as gloomy, the sky littered with clouds spitting rain. "Lance showed up in a very simple trench coat," Rupf recalls. "He looked really nothing like the personality that he actually has. As we were talking, out of his coat he brought a bottle of whiskey and said, 'I made that at home. I'm in the brewing industry, but what I really want is distilling.' I opened the bottle and tasted it and said, 'Wow, that is pretty good.' Or I probably didn't say that. I said something that wasn't totally derogatory because it was really pretty good."

Winters remembers a slightly varied version of their meeting. "He had very high standards," Winters says. "I know he's telling you a different story, but after he poured my whiskey and smelled it, the first thing he said was, 'Wow, you got a lot of oak there.' Then he tasted it and said, 'That's inoffensive.' At first I was pretty heartbroken about hearing 'inoffensive' because that doesn't sound like much to me. Later, and over the years, I learned that 'inoffensive' is actually relatively high praise from Jörg. He had his own style that I don't think was influenced by anybody else."

After warning Winters that he wouldn't get rich working at the distillery, Rupf hired him. Winters spent his probationary period training with Mannshardt, who was planning to retire. Early on, Winters pitched the idea of making whiskey to Rupf. Rupf had attempted to make a whiskey with Bill Owens, head of the American Distilling Institute, back in 1983, but there were problems with state and federal regulations. "I was a little concerned about making whiskey because it was not a brandy and therefore we couldn't

sell it directly. Brandy I could sell directly even though we still had problems with licensing," Rupf says.

Though Rupf was open to the idea, he wanted to impart his distilling ethos on Winters. "I show up wanting to make whiskey, and Jörg's response is, 'Great. Go distill those cherries. Go distill those pears. Go distill those raspberries, and when we're done with the season, let's talk about whiskey,'" Winters says. "He also wanted to make sure that I understood that we would not be making scotch, we would not be making bourbon, that we would be making our own thing. It was a really great approach." Armed with this new expertise and respect for the craft, Winters put his first batch of St. George whiskey in a barrel in 1997. The first lot was released in 2000.

When Winters wasn't making eau de vie and whiskey, he was doing many of the deliveries and building relationships with both bars and distributors. "I sent him out," says Rupf. "He's so much better at communicating than I am." Chez Panisse was one of St. George's earliest accounts. Winters has fond memories of eating occasional dinners in its kitchen, wearing shorts and sandals, after finishing his deliveries for the day. Through his work on the ground, he was able to read industry trends, much like Marko Karakasevic.

Winters, too, noticed that many cocktail menus were dominated by drinks with flavored vodkas and realized the potential of this market. Not wanting to miss an opportunity, they developed a line of vodka under the label Hangar One that was emblematic of their ethos. Their release of Hangar One's Kaffir Lime, Buddha's Hand, Mandarin Blossom and Straight vodkas in 2002 foreshadowed the strength of the Bay Area's imminent cocktail revival, which was just starting to catch on.

At the same time, Rupf was teaching distillers all over the country. It is widely acknowledged that Rupf opened the first craft distillery in America. Word got out about his good work, as well as his ability to navigate murky legal waters. He trained Steve McCarthy of Clear Creek, Randall Grahm of Bonny Doon,

Pears getting ready for fermentation at the St. George Spirits distillery. *Photo by Nando Alvarez-Perez and Vaughan Glidden. Courtesy of St. George Spirits.*

Fritz Maytag of Anchor Distilling, Lance Hanson of Cap Rock, Lou and Margaret Chatey of Westford Hill and Dave Classick of Classick Spirits. He also worked with the team at Edgefield Distillery and many classes of people at Michigan State University. His work now reverberates around the country, as he imparted his knowledge onto others.

Rupf's willingness to work with new distillers empowered a national network of people to make a career in the spirits industry. The relationships that both Winters and Marko Karakasevic developed with bartenders and restaurant professionals made their products accessible to the community. It gave bartenders the ability to speak about locally made spirits with authority. Jonny Raglin, partner in Comstock Saloon in San Francisco, remembers the importance of these early relationships. "At the beginning of the craft cocktail movement, distillation played a very heavy role in bringing the community of bartenders together. I can't think of anyone who did it more than Lance at St. George. Before them was Marko Karakasevic," he says. These relationships, which were reciprocally meaningful, were a precursor to the education that San Francisco bartenders were craving from producers. This served as the impetus for the formation of the regional chapter of the United States Bartenders' Guild (USBG), whose original goal was to foster collaboration among bartenders and to advance professional bartending.

The work that Rupf, Germain-Robin and Karakasevic did effectively renewed the country's interest in artisanal spirits and paved the way for a new generation of distillers to stand on their shoulders. In the early aughts, artisanal spirit production boomed, causing many states to rethink their post-Prohibition laws that limited their business models and, as such, their accessibility to consumers. The popularity of artisanal distillers wasn't limited to Rupf's protégés. In California, the number of new producers in the market grew exponentially. However, laws in California didn't loosen as quickly as those in other states. It took a group of distillers in 2012 to start the California Artisanal Distillers Guild (CADG) to advocate for their cause and lobby for legislation that would alleviate legal restrictions. There were twelve original members, including Winters and Marko Karakasevic. Their work eventually paid off with Assembly Bill 933 and Assembly Bill 1233. These advances, which made it easier for new distillers to sell their spirits, would not have been possible without the pioneering efforts of Rupf, Germain-Robin and Karakasevic.

The work of Alice Waters and, later, these three men situates the Bay Area prominently in the global food and drink arena and helped set the stage for the modern cocktail revival to begin.

MODERN PIONEERS

THE CONTRIBUTIONS OF FOUR PEOPLE
WHO HELPED DEFINE WEST COAST COCKTAILS

A s distillers were picking up where their forefathers left off prior to Prohibition, bartenders were embarking on their own journey. There wasn't much interest in classic cocktails until the 1980s. Most cocktail books were published before Prohibition, including Jerry Thomas' *The Bar-Tenders Guide, or How to Mix Drinks*, Harry Craddock's *The Savoy Cocktail Book* and Charles H. Baker's *The Gentleman's Companion*.

These books had long been out of print by the time the 1980s rolled around. What little was left of classic cocktails were in the bastardized form of shaken Manhattans or fruit-laced Old Fashioneds. And although tiki—a style of cocktails invented in California that called for rum and pulled from Polynesian culture—had been a craze that swept the nation for about three decades starting in the 1940s, its popularity, too, was dwindling. People who did have an interest in classic cocktails were islands unto themselves, operating independently.

There were a handful of bartenders who were such people. Whether they came at it through history, food, travel or culture, they were all pioneers in the realm of cocktails. Their work paved the way for a cocktail revival in the Bay Area. This group included Paul Harrington, Marcovaldo Dionysos, Thad Vogler and Julio Bermejo.

Harrington and Dionysos civilized cocktails with their incorporation of history. Vogler viewed spirits as agricultural products and held bars and distillers to a high standard, choosing only to carry products made with integrity. And while Bermejo's contributions don't outright fall into

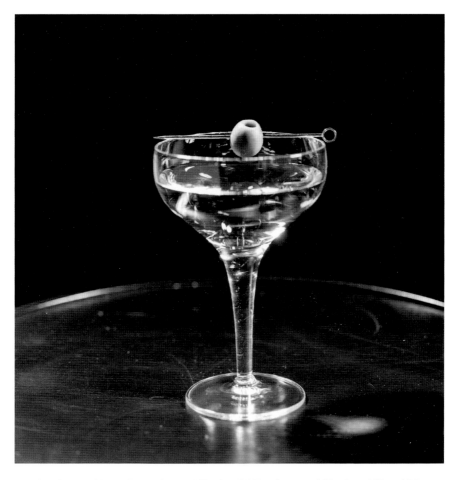

Martini. *Photo by Nando Alvarez-Perez and Vaughan Glidden. Courtesy of Hamlet and Umami Mart.*

the category of classic cocktails, his passion for tequila created the savviest city of tequila drinkers in the country, connecting spirits to terroir and cultural tradition.

What follows are the stories of each of these four men. They chronicle how they got their start bartending, their career trajectories and their contributions. Their work not only changed the way in which the Bay Area drinks but helped to define its place in history.

PAUL HARRINGTON

Paul Harrington is a familiar name to those who have been bartending in San Francisco for a long time. It is his name that is written on the binding of the first cocktail book they ever read. It's the book that sparked their early interest in cocktails. It's his prose that made them understand how romantic a Side Car can be. More often than not, his name was mentioned in my interviews. The veteran bartenders who I interviewed frequently made reference to his book, *Drinks Bible for the 21st Century*, ensuring that his significance was not forgotten. Some bartenders pulled it off the shelf to read aloud from during our interview. Others carried it to our interview and took it out to reference when talking about his influence. For many newcomers though, he is unfamiliar. They don't know that he is the man who opened the door for classic cocktails in the Bay Area. Harrington left the Bay Area before the cocktail renaissance really began, rendering himself a bit of an enigma to those he preceded, but his work created the foundation for San Francisco to become a true modern cocktail city.

Harrington—a calm, modest man with an even, confident voice—grew up in Bellevue, Washington. In high school, he played soccer and excelled in science and math. He also had a penchant for cooking. He would often make his family breakfast. This interest led him to restaurant work as a teenager, his first formal introduction to the service industry. In 1985, he moved to the Bay Area to attend UC-Berkeley. He arrived a couple weeks before school started to try out for the men's soccer team and stayed with his cousins in San Francisco. They took him to eat all over the city, something he cites as a formative experience. He majored in engineering, but like most eighteen-year-olds, he didn't feel strongly about his choice. To make money on the side, he had a brief stint as a pot dealer but quit after he realized how uncomfortable a knock on the door from a stranger made him. Between this and a major that left him uninspired, he took a sabbatical from school. He moved back to Bellevue to regroup. He sold Cutco Knives until he decided to go back into restaurant work.

"I went down to Charlie's Bar and Grill and applied for a job," Harrington recalls. He worked there as a breakfast waiter, soon realizing he wanted more. On the cusp of twenty-one, he felt drawn to the bar. By advocating for himself, he worked as a barback for a few months until he got thrown into a day bartending shift one Saturday when Charlie's was short staffed.

The flow of service came easily to him. That morning, as he was setting up, a customer sat down at the bar. "I put a napkin in front of him and said,

'How are you doing? Would you like a drink?' He ordered a Manhattan, and I knew I didn't have to look up the recipe. I couldn't tell you what whiskey I poured. I know I didn't add any grenadine or a sweetener. I just used vermouth, whiskey—I doubt I had any bitters—and a cherry," he remembers with humor in his voice. "He said it was very nice and finished it. It was one of those experiences that I think in my heart is why I was meant to be a bartender." There's something about the first cocktail a new bartender makes a guest that proves satisfying and exciting. From there, his interest in cocktails only grew deeper.

He stayed in Bellevue working at Charlie's for about a year before returning to Berkeley to resume his studies. During his sabbatical, he realized that he wanted to be an architect. With this as his new career goal, he refocused his academic efforts. But he still needed money to help finance his education, so he got a job at Houlihan's on Fisherman's Wharf in San Francisco. There, he became the bar manager at twenty-two years old.

It was the late 1980s, and drinks with artificial flavors reigned supreme. The drink menu at Houlihan's was created by its corporate office and consisted of drinks emblematic of the time. "We had a Woo Hoo and a Blue Whale, which was in a big giant plastic whale, and a Bahama Mama. There was a blended one with peach schnapps, orange juice and vodka," he recalls. As the bar manager, he wanted the blended drink to be more visually appealing, something he was "very adamant about," and added a quarter ounce of grenadine for color. "I probably got reprimanded for it, but I kept doing it," he says.

It was at Houlihan's that he met Thomas Southwell, the person who allowed him to see the importance of consistency for drink quality. Southwell had come from TGI Friday's, another corporate environment (a chain that earned historic deference for being one of the first fern bars). At that point, Harrington had little over six months of bartending experience under his belt. Even though Harrington trained him, Southwell had more years working behind the stick. It was Southwell who taught Harrington some important tricks.

Harrington says of this, "At Houlihan's, we free poured.* We had these little test tubes that you had to pour into before a shift to show that you could pour a quarter ounce, a half ounce and three-quarters of an ounce. To me, there was absolutely no use for a jigger. But Tom turned it into more of a science. When I was like, 'Here's our Strawberry Daiquiri recipe,' I would

* Free pouring is a method of measuring liquid by counting or eyeballing instead of using a jigger.

just throw it together. He's like, 'Don't you think you should use that ice scoop to measure ice?' He gave me a glimpse of what they did at [TGI] Friday's. I realized that there is actually some discipline involved in measuring and making sure a recipe is correct. It clicked with me immediately." Harrington realized that not only did measuring allow for a better-tasting drink, but it also kept the bartenders from pouring product down the drain when an excess amount was made. It was part consistency and part cost-based, but he sees it as a formative step in his career. "The precision I learned from Tom really helped me," he says.

When his industry friends would stop by the bar, he would make them special drinks. A popular drink at the time, the Kamikaze, was a boozy concoction of Rose's Lime Juice and vodka. "If other bartenders from town came by, you showed your respect to them by muddling a Kamikaze," he says. This was a precursor to the muddling craze that would take off a decade later, started by Harrington himself. "We would grab some of the lime wedges in the garnish tray and muddle that up instead of adding Rose's Lime Juice. That was as fancy as a cocktail got at that time." Cosmopolitans had also made their way to San Francisco, infiltrating the nightclub world. "If you wanted to play a trick on bartenders, you would look at the Campari bottle and use the Negroni recipe. You would make them a Negroni because it was bright red and looked like a Cosmo. But it would be an extremely bitter drink. They'd be shocked," he recalls fondly. "When I finally went to work at nice restaurants, I always made a very good Negroni for that reason."

Eventually, Harrington traded Fisherman's Wharf for Emeryville— where St. George Spirits had started—in the East Bay. He went to work at the Townhouse Bar & Grill after meeting Joseph LeBrun, the owner. His career became more serious there, as he worked to deepen his knowledge of spirits. The Townhouse was known for its selection of port, brandy and single

Negroni. *Photo by Nando Alvarez-Perez and Vaughan Glidden. Courtesy of the Thirsty Vintage.*

malt scotches. They had twelve-year old scotches, Chartreuse, several Lustau sherries, Graham's '85 port and brandy from Germain-Robin, Clear Creek and the Armagnac region of France. Harrington had weekly tastings with spirit sales reps, from which he learned much. He would taste wine every Tuesday and developed something he calls a "working man's palate." He says of this, "I can't get into explaining why they're telling you there is blackberry or dirty socks or whatever; that's not me. But I can tell you how wine feels in my mouth and if it goes with what we are serving. I've always had sort of a gut instinct reaction to beverages, like this works or this doesn't. I don't have a lot of pretense about it, but I believed in everything I poured." Later, he took over the spirit selection for the bar.

He also honed his hospitality behind the bar. He got to know his regulars and took pride in making them a bespoke cocktail based on their mood. He was a throwback to pre-Prohibition-era bartenders, those who acted as social concierges, had a large repertoire of drinks and anticipated customer needs. In short, he always made them feel cared for and welcome. To boot, he usually had cigarettes on demand. "Back then you could smoke in a bar," he says. "I built this yellow Alaskan cedar humidor in one of my architecture or woodshop classes. I'd go buy loose tobacco or buy expensive European cigarettes or small cigars and would just keep the humidor stocked with tobacco." When someone would ask for a smoke, he'd pull out the box. "They'd go, 'Oh my gosh!' It was like candy. They'd be so amazed."

In terms of craft cocktails as we know them today, the Townhouse is where Harrington realized the importance of using fresh juice. He found an Ebaloy brand juicer at the Ashby Flea Market in Berkeley. "It was very well machined. I had it in my own personal collection, and it probably traveled with me." He began buying vintage cocktail books at the flea market. "I'm a collector," he says.

Word got out about Harrington's good work. Industry friends of both his and Joseph LeBrun's would come visit. Eventually, staff from Zuni Café in San Francisco began showing up. It's not clear if the Zuni staff began using fresh juice after seeing Harrington use it or if they were doing it simultaneously. However, some feel that it was indeed Harrington who inspired them to use fresh juice, something that would eventually make Zuni's drink program a favorite in town.

Harrington caught the eye not only of fellow industry colleagues but also the local media. Pamela Raley, an editor at the now defunct *Bay Foods* publication, came in and watched him work. Brown, who was dating the editor, was under the impression that Harrington was an aspiring writer

(likely because he had listed this on his résumé to make himself seem more interesting when he had originally applied to the Townhouse). The editor asked him to write a piece for them, so he chose to write about rum. He had been affected by a Cuban cookbook called *Memories of a Cuban Kitchen*, for which Charles Schumann—a well-known London barman—had contributed recipes for the Mojito and the Hemingway Daiquiri. Harrington, who was still just twenty-three at the time, appreciated Schumann's use of fresh ingredients and took his cue from the book. "I guess that's where it started," he says. "Then I did a little bit of research." Thus, both his writing career and serious interest in cocktail history began.

Through his industry connections, Harrington met Evan Shively, a chef who was helping Rick Hackett, Meredith Melville and Mark McCloud reopen historic restaurant Enrico's Sidewalk Café in the North Beach neighborhood of San Francisco. Enrico's was originally owned and operated by Enrico Banducci and was once a staple of North Beach but had closed in the early 1990s. Hackett, Melville and McCloud wanted to give it a second life. They got Shivel to run the kitchen, and he recruited Harrington. Although Harrington didn't last at Enrico's for much more than six months, it opened a door for him that changed not only his career but San Francisco's cocktail legacy.

Harrington was largely responsible for the drink program at the Enrico's reboot in 1992. He tried to do what he had done at the Townhouse and make people a cocktail after asking them what they liked or what they were in the mood to drink. He incorporated the Mojito and the Hemingway Daiquiri into Enrico's repertoire. One night, two writers, one of whom was Gary Wolf, made their way to Enrico's when Harrington was working. "They were on assignment to write about summertime drinks in San Francisco," he remembers. "They were just two people sitting at my bar. I came up, put down napkins like I always do. They were like, 'Hey, what's a good summertime drink to have?' At that point, I don't think we had menus. I'm pretty sure I made them a Mojito or Hemingway Daiquiri and just started talking about the stories that I knew. They were scribbling, scribbling, scribbling. At some point that evening, they let me know that they were writing this article. It was an easy assignment because I had so much information and it was fresh and I was excited about sharing it. I was a source more than a talent."

After the story was published, Enrico's blew up. People came in and ordered from the newspaper. "It was really the first time when people ordered something that I hadn't told them about or sold them on," he says.

It made him uncomfortable that people were blindly following drink trends. "It was unsettling. It was not the same experience." This attention and this new way or ordering, coupled with an uncollegial co-worker, eventually led him back to the Townhouse, where he felt like he could be himself.

Wolf kept up with Harrington's move back to the East Bay and called him a little while later. Wolf was working at *Wired* magazine as an editor. His colleague Laura Moorehead and her boyfriend, Graham Clarke, pitched him a column on cocktails. Wolf greenlit the idea under the condition that she include Harrington. The next thing Harrington knew, he was at the Hotwired office, the Internet venture of *Wired* magazine, with his bag of bar tools. "I would show up, usually on a Thursday or Friday afternoon, and there would be ten or twelve writers working on the website," he recalls. "I would make drinks for them as a group and talk about what I knew of the drinks. We would assign groups of two or three people to go out and write a story about the Old Fashioned or the Side Car. They would go do the research, write something and then e-mail it to me. I would edit and change things." Thus, the "Alchemist" column was born. This was one of the first cocktail blogs to hit the Internet.

The cultivation of the "Alchemist" voice was a group effort, much of which came from Moorehead. The term "Alchemist" was pulled from an article that Wolf had written. Though there was a team working on these columns, Moorehead saw potential in Harrington. She saw him as more than someone who contributed ideas for stories. She started asking him to write articles. He was hesitant at first because he considered himself to be more of a bartender than a writer. Moorehead pressed him until he agreed to give it a shot. The two decided to work together on his first article, which went so well that they co-wrote all of his subsequent "Alchemist" columns. They did this for two years. There was a lot of material to cover, making their quest for content simple.

"The Alchemist" led to a book, *Drinks Bible for the 21ˢᵗ Century*, which he and Moorehead wrote together. The book included sixty-four recipes and took over two years to write. It was one of the first cocktail books of the modern cocktail renaissance. It went on to win awards, including a prestigious James Beard Foundation nomination.

As with the website, the book's purpose was to teach people about the basics of cocktails so they could make them at home. Because Harrington was a local, many bars bought the book and put in on their shelves. It served as a how-to manual for many of the future industry leaders in the Bay Area just a few years later when they began to cut their teeth on cocktails.

Erik Adkins, beverage director for the Slanted Door Group, first started to learn about cocktails while he was working at the Slow Club in San Francisco. "They just had lemons, limes, a hand press for juice, simple syrup and spirits. And Paul Harrington's book. That was it," Adkins says. He used this as a tool in his early days. Things then began to make sense. "It had awesome pictures and vintage drinks. Suddenly I'm like, 'Oh, I'm making a Pegu Club! That's what a Daiquiri is! Oh, that's what a Mai Tai is!'"

The same was true for Jon Santer, owner of Prizefighter in Emeryville, California. He, like Adkins, used the book when he was starting to learn about cocktails. "Todd Smith, my bar manager at Glow, gave me Paul Harrington's book," Santer recounts. "Todd was like, 'Read this. If there is one book to read, it is this one.' So I did, and that became my basis for how I understood drinks for a very long time."

Though it was published in 1998 and much has changed, Harrington stands by all of his recipes today. He's considered writing a second edition with the more complicated recipes that didn't make it the first time around but decided against it. He tested all the recipes tirelessly over the course of writing "The Alchemist" and the two years he and Laura spent working on the book. All the recipes are based on historic cocktail families, and he feels they have withstood the test of time.

Harrington's original plan was to quit bartending when he turned thirty. He stuck to this goal, leaving the industry for architecture, his other passion. Although *Drinks Bible for the 21st Century* was published when he was thirty-one, he never had a regular shift behind a bar from the age of thirty until he opened up his own place, Clover, in 2013. There, he continues to impart his skills on the city of Spokane, Washington. And although he may not be well known to the bartenders who were trained by the very leaders he inspired, his legacy continues to be a shoulder on which bartenders today stand. In fact, his Jasmine cocktail has recently been popping up on menus around the country and has earned its place as a classic modern cocktail.

Marcovaldo Dionysos

For many newcomers to San Francisco, of which there are many, Marcovaldo Dionysos is the superfast bartender from Smuggler's Cove, where he worked for six years. He's likely the first face they saw when they made it through the long line in front of the unmarked tiki oasis

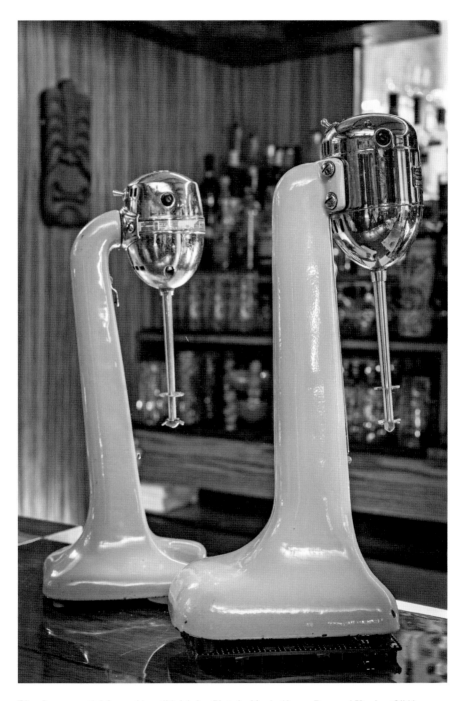

Blenders, essential for making tiki drinks. *Photo by Nando Alvarez-Perez and Vaughan Glidden. Courtesy of Pagan Idol.*

with the blacked-out windows. He's the guy who didn't bat an eyelash when they ordered eight different drinks at once and, if they watched him make their order, didn't pick up a single bottle more than once. He may be the person who dazzled them with his tiki knowledge, exposing facts that reveal his quick wit and sharp intellect. In fact, the first time I met him was at Smuggler's Cove. I was fresh off reading one of tiki historian Jeff "Beachbum" Berry's books, and we got into a friendly argument over ingredients in a syrup discussed in the book. (I was probably wrong.) Dionysos is one of the most prolific and intelligent bartenders the Bay Area has ever seen. He picked up where Paul Harrington left off, popularizing esoteric classic cocktail history. These are just a few of the reasons that he is one of the most influential bartenders in San Francisco's history. Period.

Dionysos is a native Californian. He was born in 1969 as Mark Johnson, later changing his name to Marcovaldo Dionysos (after an Italo Calvino book), in the Inland Empire. He was raised in Southern California and, later, Stockton, California. He started working in the service industry when he was seventeen. His long and illustrious career began when he was convinced by two classmates to fill in for them at a restaurant where they washed dishes so they could go to a concert. He obliged and did such a good job that he replaced them on the schedule after a weekend of work.

After high school graduation, he moved to Eugene, Oregon. Job openings were few and far between. "The economy was terrible," he says. Unlucky in employment opportunities there, he moved to Seattle, Washington, on his twenty-first birthday. He was able to land a job immediately as a dishwasher. Eventually, he got a job at a Mexican chain restaurant called Casa U-Betcha. There, he moved from dishwasher to busser. Though he liked Seattle, it was the height of grunge, and the scene wore him down. He decided to give Portland, Oregon, a try.

Portland is where he laid the foundation for his career. There was another Casa U-Betcha in town, where Dionysos was offered a busser position. He was also offered a bartending job at another restaurant but turned it down to take the opportunity at Casa U-Betcha, the busiest bar in town. There, Dionysos was offered a deal: if he bussed tables for six months, they would train him to bartend. He stood to make money, so he took the offer. He worked as a busser at night, only to clock out and train behind the bar after his shift—without pay. After he put in his time, he made management keep their word. It was there that he developed his speed, something for which he became known. "I think it was great training because I learned to be fast," Dionysos says. "We weren't making good drinks. But damn, we were

making them fast. [With classic cocktails] you may have the drinks down, but putting that extra bit of urgency is just hard. It's a hard thing to train." Most people ordered Margaritas; in fact, they stocked a combination of mixto tequilas and some 100 percent agave tequila.* This was Dionysos' first introduction to higher-quality tequila. One day, a customer deviated from the normal order and asked for a Singapore Sling. "I had no idea what to do," he recalls. He asked the two other bartenders who were working that night—both of whom had trained him—and they gave him different answers. He couldn't make his guest the proper drink, which piqued his curiosity about the actual recipe.

He went to Powell's Bookstore to try to find more information. "Powell's was one of the reasons I wanted to live in Portland," he says. "It's this amazing, full city block bookstore. One of the coolest things about it, aside from its enormity, is that it has new and used books side by side." He didn't know what to buy when he first found the liquor section. "I think the first book I bought was the *Sardi's Bar Guide* from Sardi's in New York. It wasn't terrible, but I kept going back to get more books. Initially it was for the Singapore Sling, but I found that every book I picked up had a slightly different recipe," he says. This led him down a rabbit hole, and soon he amassed a large collection of vintage cocktail books. "I would go in and walk away with twenty, thirty books sometimes," he remembers. "The books I was able to pick up were incredible. And they were cheap. I was paying $3 and $4 for books that you can't get for under $500 now." As his interest in classic cocktails grew, so did his book collection.

Dionysos ended up leaving Casa U-Betcha when it closed for a remodel. He made his way to a restaurant called Saucebox, where Peggy Boston had been hired to create the menu. "It was the first place I worked where they had lemon and lime juice separate from the simple syrup. It was maybe the first cocktail-driven bar in Portland," he says fondly of his experience at Saucebox. He learned that possibilities for innovation opened up when a sour mix was deconstructed because any type of sweetener could be added (like cane sugar, demerara sugar, honey or agave nectar). This kept his interest for about a year until he got restless and wanted to move on to a job where he felt he could continue his drink education.

Around this time, in 1996, he was approached to open a new Kimpton Hotel property in Portland. He was ready for a change of scenery, so he

* Many places in the United States were using mixto tequilas at that time, which were made with agave and something else, like corn or wheat; 100 percent blue agave tequila is of much higher quality.

decided against it and moved to the Bay Area. He intended to move back to Portland after spending a few years in San Francisco and learning as much as he could in a new city. But after moving to San Francisco and immersing himself in the industry, he never felt compelled to go back to the Pacific Northwest. The Bay Area became his new home. When he arrived in San Francisco, his first job was at Enrico's, the bar where Paul Harrington had worked a few years earlier. "They had the same menu that were leftovers from Paul's time there," he says. "They had maraschino liqueur, something I never saw. It may have been in Portland, but no one was using it. In San Francisco, if you saw a bottle of maraschino behind the bar, there was a good chance they could make some decent cocktails. They were doing Aviations, the Paul Harrington way, without Crème de Violette, which wasn't around."

He also remembers the early days of the Mojito craze that Harrington had kicked off, which was almost exclusive to Enrico's. "It sounds ludicrous now, but it was the only place making Mojitos," he says. When one of Enrico's bartenders left to open a new bar, Skylark, on Sixteenth Street and Valencia in the Mission neighborhood, he put a Mojito on the menu. Dionysos remembers that the Skylark's version was listed in the *Guardian*'s "Best of the Bay" list for "Best Relocation of a Cocktail." He says, "It was that big of a thing."

Back at Enrico's, Dionysos worked the day shifts. Because he didn't have seniority, he found it tough to get a night shift. He left to work at a nightclub. But before he left, he met Paul Hodges, one of Enrico's managers. Dionysos made an impression on Hodges. A short while later, Hodges left Enrico's to open a new place in the Hayes Valley neighborhood of San Francisco. Hodges offered Dionysos a spot on the opening team. "Hodges called me and said, 'Are you ready to do something else? Are you still at that nightclub? Want to come do something interesting? We haven't decided on a name, but we're talking about a couple different things, and absinthe," Dionysos remembers. This excited Dionysos because it allowed him to use recipes from his vintage cocktail book collection. "I just flipped out because so many classic cocktails include absinthe or come from what I consider the absinthe era," he says. This was the first conversation he had about what would become Absinthe Brasserie & Bar, one of the most influential bars in San Francisco's history.

Dionysos took full advantage of his freedom to create an inspired cocktail menu. "I thought it would be cool to tie the cocktails into the idea that they came from the absinthe era," he says. Absinthe was illegal in the United States at that point, and had been for decades, so the recipes

House-made bitters. *Photo by Nando Alvarez-Perez and Vaughan Glidden. Courtesy of Ramen Shop and Umami Mart.*

he chose tapped into the same feeling of defiance that speakeasy-style bars would later conjure.

He married his love of history and drinks on the physical menu. The cocktails had a narrative that fit with the restaurant's concept. "I put the name of the drink and a list of all the ingredients," he says. He also included a short line of who created the drink, where it came from (like New Orleans) and what book the recipe was from. "I feel like story is important, like some kind of context. Otherwise, it's just a bunch of words on a page. If you have a story, it makes the experience much more compelling."

In addition to the historic drink references on the menu, Dionysos took advantage of having access to a great kitchen. Though the bar's relationship with the kitchen was adversarial at times (he had to fight for space in the walk-in refrigerator), he was able to make some of his own ingredients. He made ginger syrup from scratch and used it in his Ginger Rogers cocktail, the first drink for which he became known.

When Absinthe opened in 1998, the menu took off. People started coming in for the cocktails, rendering the wine program secondary. One night when Dionysos was tending bar, he looked up and saw that everyone was drinking a cocktail from the menu—no beer or wine—which was a remarkable change from the norm. The kitchen was open until 1:00 a.m. daily, so it quickly became a favorite spot for other bartenders around town to visit after their shifts ended. Scott Beattie, author of *Artisanal Cocktails*, cites Dionysos as the reason he became interested in cocktails. In his book, Beattie writes about his first experience at Absinthe: "About two years into my bartending career, I ordered a drink from Marco at Absinthe that would radically change my perspective. Marco designed many original drinks and resurrected a few dozen recipes from classic cocktail books and magazines. His Ginger Rogers was a perfect blend of gin, mint, lime juice, house-made ginger syrup, and soda. It was unlike anything I'd even tasted….I knew after those first few sips that I wanted to make drinks that tasted like that."

Erik Adkins also remembers visiting Absinthe in the early days. "I remember going into Absinthe and being completely befuddled by the fact that they had this vintage cocktail list that had cited books," Adkins says. "It seemed like such a bizarrely tiny niche to me, almost like a gimmick. I remember sitting at the bar and eating coq au vin and drinking red wine because I just still couldn't wrap my head around the cocktails. And there were two bartenders behind the bar. One was very old and had a tiny cobbler shaker and did the daintiest little shake with it. The other one was tall and handsome and very fast. I would see him use his bar spoon to the clear ice cubes that would fall on the tray. He had this kind of fast flair about him. Of course, that was Marco Dionysos."

Dionysos worked as the bar manager at Absinthe for three years before he grew tired of some issues he was having with other managers and the kitchen staff. But before he left, he began working a couple days a week at Stars with Peggy Boston, his former Portland colleague. Stars was one of the best restaurants in town* and a much coveted gig. (In fact, Paul Harrington had always aspired to work there.) They were doing innovative things with food and the physical space. "The idea of an open kitchen, herbs in cocktails and common tables are almost ubiquitous now," says Neyah White, former bar manager of Nopa. "Fifteen years ago, any one of those concepts is completely and totally groundbreaking. The common table is a bar out in the dining room. The herbs in the cocktail is the kitchen out on the bar. The open kitchen, being able to sit down and watch things be prepared, that's the bar stretching back into the kitchen. I think Jeremiah Tower of Stars got that going."

However, it was Harry Denton who got Dionysos to fully leave Absinthe. Denton owned and operated the Starlight Room, where Tony Abou-Ganim had worked. Abou-Ganim put together the drink program there, earning it acclaim. Abou-Ganim went on to become one of the most influential bartenders in the country when he moved to Las Vegas and ran the bar at the Bellagio Casino. Dionysos and Abou-Ganim had met before he moved to Las Vegas. Abou-Ganim's drinks impressed Dionysos, and Abou-Ganim was dazzled by Dionysos' deep knowledge of cocktail history. When Dionysos heard that Denton was working on a new project,

* Stars opened in 1984. Chef Jeremiah Tower had worked under Alice Waters at Chez Panisse. Stars was immediately renowned and was one of the highest-grossing restaurants in the country. It earned a reputation for its innovative approach to food and design. It launched the careers of many esteemed chefs, including Bay Area darlings Dominique Crenn of Atelier Crenn, Mark Franz of Farallon, Tim Gable of One Market and Loretta Keller of Coco500.

he saw it as an opportunity to further his career. The project was called Rouge, and Dionysos set up the program.

Ultimately, the days of Abou-Ganim were over, and he didn't find his groove at Rouge. He went back to Enrico's in North Beach. This time around, there was a small community of like-minded people forming in the neighborhood. David Nepove, a hungry young bartender from Southern California, was working there, and the two began to spend time together. "Marco, one of my best friends, is also my mentor," says Nepove. "When I was at Enrico's, he would share with me some of his passion for classic cocktails. That was when my bartending career began to change. He taught me a lot."

They were usually joined by Todd Smith, who managed Glow across the street, and Jon Santer, who bartended at Glow. Santer, who had moved to the Bay Area from Santa Fe and had aspirations of becoming a writer, was focused on economy of motion as a new bartender. "I learned a lot by watching Marco move," Santer says. "I would drink soda water and watch him work. He was really fast and efficient, and he looked good. He did things in a way that I hadn't seen anybody else do. And he took it really seriously."

The four of them—plus a fresh-faced South African bartender, Jacques Bezuidenhout, who worked in the Financial District—would often get together, foreshadowing the strong bonds that would tie the Bay Area bar community together. "I was suddenly in this environment of these guys who took bartending really seriously," says Santer of this time. "They knew all kinds of cocktails and would talk about them. These guys were really good at what they did." Dionysos was at the heart of this burgeoning community.

Dionysos continued his habit of working multiple places at once. While at Enrico's, he also worked at Vesuvio, another North Beach bar famous for its historic customer base of beatnik writers, like Jack Kerouac. When he later left Enrico's for good, he worked simultaneously at Bubble Lounge, Moose's, the Starlight Room (Denton wanted him to revamp Abou-Ganim's program) and Cortez. He eventually landed at Tres Agaves.

Tres Agaves was a restaurant that celebrated Mexican food and drink near the Embarcadero in San Francisco. Julio Bermejo, Dave Stanton and Eric Rubin originally owned it. Bermejo, as we'll see later in this chapter, is a tequila expert who made the Bay Area the savviest agave market in the country. He runs his family's business, Tommy's Mexican Restaurant, in the Outer Richmond. Tres Agaves was his first venture outside of Tommy's. He put together an incredible bar team, including a few famous bartenders from London, to run the show.

When Tres Agaves opened in 2005, it was busy from the start. The restaurant needed fast bartenders, and Jacques Bezuidenhout, the bar manager, worked hard to bring Dionysos on board. Dionysos had known Bermejo for some time, as Bermejo had often come into Absinthe as a guest. Dionysos had also been visiting Tommy's to learn more about tequila from Bermejo. So Dionysos eventually joined the team. Dionysos' interest in tequila dated back to his early days of bartending at Casa U-Betcha. He jumped at the opportunity to learn more about the spirit and immersed himself in education. Around this time, cocktail competitions were starting to become popular. He entered a Herradura tequila competition and won. For his win, Herradura took him to Mexico. He ended up traveling to Mexico two other times with Tres Agaves.

This led to his involvement with the Tequila Interchange Project (TIP), a group intended to educate people on sociocultural, economic and scientific issues related to agave spirit production. TIP is composed of bartenders, producers, professors and lawyers. "I think it's a great program," Dionysos says. "Information from TIP gets to the level of bartenders who can then go disseminate that knowledge to customers." As San Francisco is one of the biggest markets for agave, this has been an important part of educating a sophisticated drinking public and helping to inform them of their consumer choices.

The Bay Area is the most knowledgeable market on agave spirits, including mezcal. *Photo by Nando Alvarez-Perez and Vaughan Glidden. Courtesy of Hamlet.*

In 2008, after leaving Tres Agaves, Dionysos went on to Clock Bar, a bar owned by Chef Michael Mina's restaurant group. There, he was able to grow his relationship with the kitchen. The chefs made him whatever ingredients he wanted from scratch. "It was magic," he says. Clock Bar pushed him to experiment with new flavors. He was able to put his drink, the Chartreuse Swizzle, on the menu. This cocktail had scored him first place at a Chartreuse cocktail competition back in 2003. It began to take on a life of its own after Clock Bar. The drink started to show up on menus in other places, including later

46

as a new tiki drink at Smuggler's Cove. He left Clock Bar because of issues with the operations management and union rules. He took a job at Rye in the Tenderloin neighborhood and worked there for a couple of years before transitioning to Smuggler's Cove.

Smuggler's Cove opened in 2009 by Martin Cate, a tiki enthusiast turned tiki bar owner. It was Cate's second bar and was an instant hit. The menu was long and unlike those typically found in traditional cocktail bars but became instantly popular. Dionysos approached Cate, whom he had known for several years, about a job. Cate wanted Dionysos to commit to the bar for at least a year. Dionysos stayed for over six, helping it to earn international recognition and making it his longest gig to date.

Tiki was a new world for him. "Tiki is something that I don't get at all, so that was enough to keep me there," he says. Tiki drinks often have eight or more ingredients, making them layered and complex when executed properly. "Balancing eleven ingredients is crazy, but it works. It's fascinating, and it's difficult. It's like trying to do Sudoku on horseback."

Dionysos remains active in the Bay Area's bar community. Though he has since moved on from Smuggler's Cove, his thirst for knowledge has not subsided, nor has his interest in classic cocktails. He's been an outspoken leader who has pushed his colleagues, bosses, spirit companies and even customers to work harder and drink better. He's been a prolific bartender whose influence is hard to quantify but incredibly easy to qualify. San Francisco would not be where it is today without him.

Thad Vogler

Thad Vogler is hard to miss. At six and a half feet tall, he is a strong physical presence. He can often be found tucked in the back booth of one of his bars, running drinks to tables during service hours or making adjustments to the furniture in the dining room. He's also known for his intellect. "He's just got this presence and he's a smart guy," says Erik Adkins, Vogler's longtime friend. "It's a little more work than some of my other friends because you've got to pay attention, but it's always fun being around him." His stature only grows when looking at his place in contemporary cocktail history, where he's been an important leading figure.

Vogler, named after a character in *Death in Venice*, was born and raised in Santa Cruz, California. His father, Thomas Vogler, was part of the founding

Thad Vogler. *Photo by Jon Santer.*

faculty at the University of California–Santa Cruz and co-founded the History of Consciousness department (famous for faculty member Angela Davis). His parents divorced when he was young. He later split time between California and Olympia, Washington, when his mother moved there after she enrolled in Evergreen State College. He grew up in a relaxed, if fractured, environment, which was not for him. He craved structure and discipline. He liked teachers who pushed him. He liked coaches for the same reason, as well as the "linear quality of how to succeed," on sports teams, as he explains it. In fact, he was recruited to Yale to play basketball. He played on the team for a year and a half.

Yale is what led him to his first bar job. He started working at the Yale Repertory Theater in 1988. He worked behind the bar during intermission, quickly serving guests before the lights dimmed, and then headed into the theater to watch the plays. At Yale, he was an American studies major and an aspiring writer, so this felt like an appropriate use of his time. "The Yale Rep is an old and esteemed theater, and tons of people have been through Yale Drama," he says. Though he wasn't yet making cocktails—"I was just pouring wine and maybe making Gin and Tonics," he says—he began moving toward his career in hospitality.

From the Yale Repertory Theater, he got a job at Robert Henry's, a French restaurant in New Haven, Connecticut. "That's where I fell in love

with service," he recalls. "I worked there for two years as a busboy; it was my favorite part of the day. It had the simplicity of sports. It was a physical process that involved grace and attentiveness and efficiency. I liked the clarity of the role. It was satisfying to be good at it."

In addition to service, he also enjoyed the social aspects of the job. He found comfort in hanging out with the waiters after a shift. It was then when he first learned about cocktails. The maître'd had a penchant for Pink Gin, and guests frequently ordered Martinis and Manhattans. He stayed at Robert Henry's until graduation.

After earning a diploma from Yale in 1992, he backpacked through eastern Europe for a few months. When he returned to the United States, it was to the Bay Area. He got a job as a barback at One Market in San Francisco. There, under bar manager John Hoolihan, they made fresh juice daily and used egg whites. His penchant for structure kicked in, and he became dedicated to becoming the best barback possible. "We were tested on what everything was behind the bar. It had a really strong education program," he says. He worked there for two or three years, leaving only to travel more. He stayed abroad for two years and worked at bars in France, Ireland and Tokyo.

When he came back, he tried working outside the industry. He worked at Oracle as a compensation analyst for two years but was unhappy. He knew this job wasn't a good fit, so he returned to hospitality. After a brief stint at Belon, he got a job behind the bar at Farallon. He worked under Michael Musil, an old friend of legendary New York bartender Dale DeGroff. Musil taught him about making cocktails. Vogler says of Musil, "He collected books. We were making Sazeracs, very much like what people are doing now. We were free pouring but had no soda guns. All sodas came out of a ten-ounce bottle. That was definitely significant."

They were also using raw sugar, something that was not yet ubiquitous. "Michael was already adding sugar to simple syrup, adding less water—dilution—and thinking about ice. He used confectioners' sugar because it dissolved almost immediately." They stirred Manhattans and also used egg white in a few cocktails. Musil went beyond technique. "He was also a great service guy," Vogler posits. "His philosophy was of an era." He began using a jigger in 1993, although he says that "arguably the main reason was to make sure liquor costs were right."

As Vogler was working at Farallon, the California style of cooking was taking root in San Francisco, and chefs were thinking about seasonality, production quality and freshness of food. "I think the idea was very much

fashionable and established in the Bay Area," Vogler says. "At Chez Panisse, Square One, Zuni and even One Market, there was this farm fresh idea." This opened him up to new ideas that he would later incorporate into his own programs. He stayed at Farallon until 2002, when he left to run the bar at chef Charles Phan's Slanted Door restaurant.

Vogler was the Slanted Door's first bar manager after it got its liquor license. He was attracted to working with Phan because he was doing farm-specific dishes, employing the farm-to-table concept. "I was interested in agriculture and in food that was agriculturally driven," he says. Vogler's appreciation of this began to trickle down into spirits. He started to think of them as agricultural products, an ethos for which he is now famous. "I didn't say, 'Ah ha—agriculture!' It started with food. Slowly and gradually, like anything else, I started to realize that spirits are made of the same stuff as food and wine. But we didn't always think about it that way. Gradually, I'm becoming more interested in ingredient-driven food while coming at it through the back door of spirits," Vogler says.

At the Slanted Door, Phan gave Vogler the freedom to design the drink program in the way he wanted. This autonomy allowed him to question the quality of various products. "It was like, why are we selling stuff that has artificial colors and flavors? Why are we selling stuff that has industrial sweeteners?" he remembers of this moment. "I threw out more and more stuff that was shitty. When I weeded that stuff out, I realized that I was getting closer and closer to the agricultural origin of whatever the product was. I ended up with good brandy, agricole rum and scotch. There's a sense of place. Generally, the agricultural component is the base ingredient—that's tequila, mezcal—something that is significant." Vogler is not as interested in innovation as he is tradition, setting him apart from many other industry professionals. He uses concept as a framework for curating his spirit selection. He looks at the simplicity of a product, its history and its paradigm. "Bars are about archetypes. Everything I sell is very archetypical and long established."

Adkins, who worked closely with him at the Slanted Door, remembers watching Vogler find his voice. "He just stopped ordering product and pared everything down. He made it super simple. He got away from a lot of the branding and actually looked at the bar as an extension of the kitchen. And it made sense. The wine program was very agriculturally based. The food comes from the Alice Waters school. He wanted the bar to be like that," Adkins says.

At this point, no one was really talking about where spirits came from, what they were made with or how they were made. Vogler realized that he was

more aligned with distillers than other bartenders. He felt kindred to Lance Winters at St. George Spirits and liked Ed Hamilton, the rum producer, and Charles Neal, the calvados importer. When he would taste their spirits, he had an immediately positive response, as opposed to when he tried products of inferior quality. "It was like, oh right! This is good shit," he says.

Bartenders weren't interested in talking about these issues either. Restaurants would have locally sourced food menus, but bar managers didn't apply those ideas to their back bars, causing the whole program to be incongruous. This meant that bartenders weren't given the opportunity to start thinking about spirits in the same way as food at work. And most didn't get there on their own. Vogler was an island unto himself, with Phan in his corner. This unconditional support was rare from restaurant owners and allowed Vogler to become who he is today.

In 2005, Vogler took another hiatus from hospitality and moved to Guatemala for a year. Adkins took over the Slanted Door's program and kept Vogler's philosophy in place. When he came back from South America, he began consulting on bars. He set up the bar programs at De Jardinière, Coco500, Camino, Presidio Social Club and Beretta. He worked for about six months at Bourbon & Branch, a speakeasy-style bar that opened in 2006. There, he saw that alcohol should ideally be accompanied by food (Bourbon & Branch did not have a kitchen), something he has carried with him. "Normal people can't have three cocktails. They get too drunk and too sick," he asserts.

It was around this time when he started to become more vocal about his dislike for brands that weren't transparent about how they were producing their spirits. Many companies were more concerned with mass production and spent most of their money on advertising. In 2007, he wrote an essay for the Tablehopper website called "Thad Vogler on Drinking Responsibly." He defends his philosophy, which he refers to as regionalism.

The introduction of the piece, which reads, "Thad Vogler takes liquor seriously. This is not a frivolous pastime or haphazard hobby," sets more of a self-righteous tone than the piece intends. Vogler begins by drawing the connection between drinks and history by saying, "The bar is fascinating because it is one place where we are so directly connected to our cultural history." He draws a few more parallels this way before bringing up regionalism.

He writes:

Much of the history of the cocktail is about regionalism. Canonical cocktails like the Gimlet, Daiquiri, Mojito, Caipirinha and Sidecar are tied

to the places that made them famous by their ingredients. Rum, applejack, scotch, vodka—all of these are the result of regional invention. Liquors were conceived from what's at hand: molasses, apples, barley, potatoes. Great cocktails from around the world are usually a mixture of these local spirits with other regional ingredients. They were the product of creative resourcefulness. They speak of the history and tradition of the places that spawned them. Most recipes are the result of someone taking what was available in a very specific time and place and mixing it together in a certain way. In a great cocktail there is a history lesson; we learn of agriculture, war, or trade.

This paves the way for his thesis.

So why would we commit ourselves to brands and distributors who want to saturate the market? Why would we choose companies who would put small distilleries out of business, companies who are more committed to putting their product on every back bar than they are to making something beautiful? Large distilleries often resort to more and more expedient means of production while spending more money on marketing than production....I prefer not to buy and sell spirits from multinationals that make it difficult for small distilleries to survive....The quality and uniqueness of the spirits that go into our drinks are what make them wonderful. Learn what you are pouring and ordering. Use liquor from small distilleries that do things by hand and are connected to their region. You may spend a little more but you will be strengthening the tradition of the cocktail.

He used this opportunity to be transparent about his philosophy, hoping to get others to understand his perspective. Because he didn't care about maintaining relationships with multinational companies, he cited specific brands that he did not like. While some commended him for his courage, it proved problematic for others. In fact, this article cost Vogler his consulting job at the Presidio Social Club.

Undeterred, he began to think about opening up his own place. He knew he wanted to serve food, so this became a priority. "I talked about the idea so much that it became refined, refined, refined, refined, refined," he says. After a few years of planning, he opened Bar Agricole in the South of Market neighborhood. There, he was able to put everything that he had worked toward into practice on his own terms. He worked with bartender Eric Johnson, who became one of his business partners, to create a cocktail

program that privileged history and conjured a sense of place. There are no bottles on the back bar, allowing the drinks to speak for themselves. It opened with immediate success and is considered one of the best bars in the Bay Area. Bar Agricole has earned acclaim for its drink program, food and design, solidifying Vogler's legacy. In 2014, he opened a second place, Trou Normand, in the Financial District of San Francisco, employing the same ethos in an equally refined space. In 2017, he opened Obispo, a rum-focused bar. Not only has he established three places where his penchant for using high-quality products made with integrity is manifested, but he also has the ability to train a new generation of bartenders to think deeply and act in an intentional way. "I haven't hired a bartender in five years," he said in 2014. "I just bring people on with no experience and teach them. There is an infrastructure of older bartenders teaching new bartenders and a tradition of sourcing."

Vogler's work to change the way in which we value spirits is slowly taking hold. It took about a decade for his ideas to catch on, but more industry professionals are paying attention to what they carry at their own bars. The principles that he instituted in the Bay Area have started to make their way into bar programs around the country. Several of the bars where he consulted, like Beretta, have become beloved. Many of the bartenders with whom he worked went on to open their own bars, like ABV. Because of their time working with Vogler, they are choosing quality above all else.

Vogler is the embodiment of the merging of agricultural and spirits, theory and practice. His approach has earned him deference from his peers, the industry and the public that will last long into the future. He has also helped to elevate the perception of bartending, benefiting everyone in the industry. "Thad has a way of making anything you do seem acceptable," remarks Adkins.

Julio Bermejo

The first time I walked into Tommy's Mexican Restaurant, I was struck by its modesty. Nothing about its décor, which is indiguishable from other neighborhood Mexican restaurants, told me that I was at the single most important place for the American tequila revolution. I had heard a lot about its keeper, Julio Bermejo, and the breadth of his tequila offerings. I knew that he was often in Mexico but could sometimes be found behind the

bar serving his fervent followers. I made my way through the restaurant, past a row of leather booths filled with laughing people, and stepped into a small bar. There was Bermejo, a short, thin man. Though it was packed, he came over immediately and said hello, introducing himself. I managed to get a seat in front of him, and for the rest of the night I watched him greet customers, take orders and chat with longtime regulars. From time to time he would check in with me, graciously offering to pour me different types of tequila. He told me a little bit about each one, imparting a little bit of his wisdom on me each time. I knew this was the first of many trips to Tommy's.

Although tequila is a category of spirit and not specifically a cocktail, it is uniquely important in the Bay Area. It's a spirit that many bartenders revere because of its diverse terroir, history and cultural value. Julio Bermejo is the man who made the Bay Area, if not the country, understand its greatness. The Bay Area's cocktail renaissance isn't singularly about the drinks but the spirits and culture driving them, which is what makes Bermejo one of its most important figures.

Bermejo is a native of San Francisco. He came from humble beginnings. His father, Tómas, immigrated to the United States from Mexico under the Bracero program. Tómas and Bermejo's mother, Elmy, were originally from Oxkutzcab and Aquiles, respectively. Before joining the Bracero program, the couple had two children. Elmy initially stayed behind in Mexico to raise their family, but when Tómas decided to settle in San Francisco, Elmy followed. They had three more children when they reunited, later bringing their first two to the United States. Bermejo is the youngest of the five and remembers meeting his two older siblings for the first time as a child.

Tómas and Elmy opened Tommy's Mexican Restaurant in 1965 in the Outer Richmond neighborhood of San Francisco. Tómas worked the line while Elmy ran the dining room. Bermejo was a year old when his parents opened the restaurant, of which he has vivid memories. "We lived above the restaurant, so my early memories are basically intertwined with the restaurant business," he says.

As a child, Bermejo worked at Tommy's as an ingredient gopher before taking on bigger roles as a teenager. Thus, his long career at the restaurant began. Though running the family business wasn't his early aspiration, he always admired his parents' work ethic. "I never heard my father say he was tired until the last two or three years of his life. Never. It was literally my mother and father doing everything," he asserts.

He continued to work at Tommy's on nights and weekends throughout college. He attended the University of California–Berkeley, majoring in international relations. It was his dream to work at the State Department as a diplomat. He pursued this career path after college but was unable to make it through the oral exam, dashing his hopes. Instead, he continued working at the family business. "In an immigrant business," he says, "it's said that the first generation makes it, the second one keeps it and the third one loses it." He decided to not only keep it but to make it better.

And make it better he has. It is now an international destination, lauded for its selection. Working at Tommy's allowed Bermejo to fall in love with tequila and turn it into one of the world's most famous tequila emporiums. Though it's a bar for tequila aficionados, it's a place where novice tequila drinkers are welcome, too. The bottles arranged on the shelves have been collected by Bermejo over the years he spent talking to liquor reps and distributors and from his travels to Mexico. Not only does it have an internationally acclaimed reputation that draws tourists from home and abroad, but it is a staple in the Richmond neighborhood. It feels like home to anyone who walks in.

Bermejo's journey to becoming a leading authority on tequila is a serendipitous one. When Bermejo was growing up, he would travel to the Yucatan every other summer (alternated with Disneyland in Southern California). He learned to drink during these summers as a teenager, influenced by his older cousins. He started with cheap Mexican beer. "And then it was brandy," he recalls. "It was Presidente if you had no money. It was Don Pedro if you had a little money. Or it was Bacardi Anejo. Even though Bacardi Anejo had been discontinued worldwide, it was still being made in Mexico for the Mexican market."

It was also on his trips that he started to see the merits of tequila when he got a bit older. "I had an epiphany with tequila," he says. "I stopped drinking rum and brandy and being hungover. I started drinking 3Gs. That was the best tequila we had at Tommy's. It was top of the line. It just tasted very different." These brands were made from 100 percent agave. They were not mixtos—a combination of agave and another base like corn or wheat or something artificial. Mixtos often have artificial ingredients added to them, which is why they are now considered to be lower quality. At that time, mixtos were widely sold in the United States. The experience of trying his first 100 percent agave spirit opened a new door for him, and he became interested in trying similar types of tequila. One of the higher quality tequilas he tried was Herradura Reposado, a brand that would serve as a gateway for him. "Boy, did that blow my mind," he says.

Bermejo got more curious about tequila after his experience with Herradura, which he would eventually use in Tommy's house Margarita. Newly armed with the knowledge that better tequilas were made from 100 percent agave, his curiosity was piqued. He voraciously consumed every bit of information he could about tequila. He would study the labels on bottles. When he tried something that he liked, he would make a note of the distiller's name. One of these distillers was Don Felipe Camarena, who made El Tesoro. Bermejo felt an urgent need to meet Don Felipe.

He called the importer Robert Denton (whom he describes as the godfather of tequila in America) to see if Denton could arrange a visit to Jalisco, Mexico. Denton told him that Don Felipe wasn't yet ready to host any visitors. "I had no idea what they meant," Bermejo says. "I didn't want to get hosted; I just wanted to see this place and confirm that it was the greatest thing since sliced bread." Don Felipe held Bermejo off for a couple more months until Bermejo couldn't wait any longer. "Forget it. Bob, I'm going," he recounts.

In 1990, he made it to Arandas, a highlands region of Jalisco, where El Tesoro has its production facility. He showed up at the distillery, and somehow, he was able to meet Don Felipe without an appointment. After touring the distillery, the two sat down to talk. "The willingness to share his time and knowledge past business hours was very, very special," Bermejo says.

Don Felipe would become one of Bermejo's greatest mentors. From him, Bermejo learned how to formally taste tequila and develop his palate. He also met Carlos Camarena, Don Felipe's son. Carlos was able to help him break down the flavors of what he was drinking. Carlos helped him distinguish the good from the bad and acquire a vocabulary to talk about what was in the glass. He also met Don Felipe's daughter, Lilly Camarena, who would eventually become his wife. Bermejo likens his first meeting of her to love at first sight. However, their timing was never quite right, as one of them was always in a relationship with someone else. Bermejo's pull to Lilly was strong, and he held out the hope of someday being with her. He would ask her on a date from time to time but was careful to maintain a professional relationship with her. This went on for ten years until he finally decided to lay it all on the table. He flew to Mexico, showed up at the distillery unannounced and asked her out. This time, she finally said yes. They were engaged by their second date and have been together ever since.

After Bermejo's initial meeting with Don Felipe, he started going to Mexico every six weeks. These trips, meant to further his education on

tequila, became a big part of his life (though they were partially due to his "courtship" of Lilly). His lessons in tequila started with the land. He compares the romance he felt for agave fields with the first time he saw wine vineyards in Napa Valley, California, and in Europe, as he was overwhelmed with beauty. He studied the nuances of agave growth cycles and why they require patience to cultivate. In fact, certain types of agave species can take up to one hundred years to mature (though blue weber agave, the type used in tequila, takes about six to fourteen years to mature). "Things take time and need to be done in a certain way," he posits. He remembers being told by Don Felipe and the Gonzalezes of Cerrito Alleges tequila, "We're farmers. We live by the land. The land has been giving our family's sustenance and opportunity for hundreds of years. We value and take care of that."

These trips and tastings with distillers inspired Bermejo to carry only 100 percent agave at Tommy's. He wanted to convey his newfound passion for tequila to his guests, and the only way he could do that was by carrying products in which he believed. This caused the restaurant's overhead to be high, but he didn't care. "If I had been working at a corporate establishment, I would have been fired because we didn't raise prices high enough," Bermejo asserts.

However, his customers didn't yet understand why 100 percent agave tequila was better than a mixto tequila. "They tasted the difference, but I didn't have enough time to explain to every person what we were doing. It took people years to catch on," he says.

So he put together a tequila menu for Tommy's, highlighting his favorite brands. He would bring his menu down to Mexico on his trips and ask distillers for their feedback. One distiller, Guillermo Romo de la Pena (fondly called Don Memo) of Herradura, told him that while his efforts were strong, the menu was too subjective. Don Memo said to him, "You cannot say that one brand is the best. Describe your product in your tasting notes." Bermejo immediately realized the importance of this lesson. From then on, he let his guests at Tommy's decide how to feel about each tequila.

One of the vehicles that Bermejo used to highlight the difference in tequilas was Margaritas. He thought that if pour costs for ingredients were going to be high, customers should taste the quality for which they were paying. "People were not as apprehensive about Margaritas as they were shots. That really worked. And boom—everything fell into place," he says.

The first time Bermejo made me a flight of Margaritas, I was blown away at how well I could taste each expression of tequila. I tasted how the vegetal qualities changed depending on from where and by whom the

tequilas were made. Like me, Bermejo's customers notice the difference, too. "People would ask me for different kinds of Margaritas, so we just changed the tequila. People were shocked when it tasted differently." His guests began discussing which version they liked better, and consequently, they became more interested in tequila itself. "I got great satisfaction from that," he says.

To continue sharing his love of agave with his guests, Bermejo started a tequila club. The program involves tasting and includes three levels: Masters, PhD and Demigod, each requiring a rigorous test. There are over eight thousand members of the club, eight hundred of whom are Masters. "The goal was and is to help people learn about tequila," Bermejo explains. He's aware that it has become "a little cultish," but the reward of passing the PhD level is the opportunity to visit a distillery in Mexico with Bermejo.

Bermejo also put Tommy's on the map for its Margarita variation. When Tommy's first opened, Tómas was making Margaritas with mixto tequila, Triple Sec and lime juice. When Bermejo took over, he replaced the mixto with 100 percent agave tequila, swapped the sour mix for fresh lime juice, traded the simple syrup for agave nectar when it was introduced in the mid-1990s and dropped the Triple Sec completely. This version—100 percent agave tequila, fresh lime juice and agave syrup—became known to the world as Tommy's Margarita. Officially, it is a variation on the Daisy, a classic Mexican cocktail. The American version was perfected by Bermejo at Tommy's.

Bermejo believes that it was either Henry Besant or Dre Mosso who formally branded his Margarita as "Tommy's style." He first saw the Tommy's Margarita on another bar's menu in London around 2001. "To have the quality of people in London respect my work, Jesus Christ, it sent chills down my spine," he says. Also in London, a few years later, Bermejo met Tómas Estes. Estes was a restaurateur in England. When the two met, they discovered they had a mutual love of tequila. They became fast friends. Eventually, Estes became a partner in Ocho Tequila, a label that is produced by the Camarena family, now Bermejo's in-laws.

In 2003, Bermejo became Jalisco's sole U.S. tequila ambassador, allowing him to realize a part of his childhood dream of being a diplomat. This role came out of his invitation to serve as a tequila expert on a trip to Europe. He traveled to London and Paris for the signing of an agreement with the European Union to recognize tequila as a denomination of origin

spirit.* He had to give presentations and tour bartenders around tables where distillers had their products. He considers this the true start of his international career.

It was there that Bermejo noticed a sea change with tequila in America. "It was overwhelming because every bartender had so many questions. People gave a shit. It was amazing," Bermejo says. Finally, people were starting to engage with tequila in a meaningful way. At one of the dinners, the president of the National Chamber for the Tequila Industry, Francisco Gonzalez, son of Don Julio Gonzalez, decided that Bermejo needed official recognition for his work. Estes was also there, and the Mexican government made them both official ambassadors, Bermejo to the United States and Estes to the United Kingdom. Later, a third ambassador to Asia was named, but they were the first of their kind.

Bermejo takes this role seriously. "I interpret my role as ambassador, being someone who commercializes tequila, as an obligation to try to represent as much of the industry as I can. At Tommy's, we try to carry at least one product from every distiller that will export to the state of California. I'll try to carry a contract from a distillery that doesn't export a brand the distillery owns. I see that as my obligation, as well as to put aside my personal preference and try to speak as subjectively as I can about a brand. This stems from what Guillermo Romo de la Pena taught me. My ability to do so is not just based on sales sheets but taking time to visit each distillery," he says.

Since then, Bermejo's distillery visits have gone deeper than what the public can access. When visiting a new distillery, he always requests a chemist, the owner or someone intimately familiar with the product. He is treated well at distilleries; everyone knows who he is and how important his work has been. When he speaks about tequila with the distillers or with someone like me, it is immediately obvious how much knowledge he has and how easy it is for him to share it. He has dedicated his life to the category, changing the way in which we imbibe the spirit.

More than that, seeing Bermejo in Mexico is a reward in and of itself. When he is there, tension leaves his face and his whole body seems more at

* Denomination of origins is much like appellation of origins for European wines and spirits. They are a set of standards that producers must meet to call their product by a certain name. Usually this is dictated by where the spirit is made or by what production methods. For instance, champagne is technically only produced in Champagne, France, and cognac is only produced in Cognac, France. In Mexico, tequila can only be produced in Jalisco and must be made with blue weber agave. There are 180 municipalities in five states in Mexico that can technically produce tequila. This is overseen by the Regulatory Council of Tequila, or the CRT, a branch of the Mexican government.

Resting spirits at St. George Spirits. *Photo by Nando Alvarez-Perez and Vaughan Glidden. Courtesy of St. George Spirits.*

ease. Mostly, he looks so at home because his wife, Lilly, lives there. She lives in Arandas and runs Tapatio, her family's distillery. This is one of the main reasons why Julio spends so much time in Mexico.

Back in San Francisco, Bermejo was an opening partner at Tres Agaves in 2005. He ran the bar program with Jacques Bezuidenhout, a bartender with whom he had developed a close friendship. Bermejo, who had been spending time in England, hired two bartenders, Charles Vexenat and Stefano Francavilla, from the Lab Bar in London. "Julio was super enamored with them. He called them rock stars and thought they were amazing," says Ryan Fitzgerald, a bartender on their opening team. The standards for the bar staff were high, and the rest of the bar team were required to audition. Fitzgerald was one of the bartenders who had to try out. "That was intense," Fitzgerald remembers.

The idea was to tell the story of tequila through tastings. Margaritas were hugely popular at the time, so Tres Agaves was busy from the start. "It was Tommy's writ large," says Jon Santer, who bartended there. They were making Tommy's Margaritas and variations, as well as serving Mexican food with quality ingredients. Though Tres Agaves was a moneymaker, the relationship between Bermejo and his business partners became strained. He pulled out of the partnership, which led to the remaining owner's decision to change the restaurant's name to Tres.

Through all of his work, a community has sprung up around him. He hosts a number of events and fundraisers at Tommy's and has provided a space for people in the industry to come together. He has had the opportunity to teach the industry about tequila, allowing them to grow their own appreciation of the spirit. As a result, Tommy's has become a sacred part of the Richmond community where neighborhood people can come for a reliable meal. When Bermejo is there, his comfort behind the bar is palpable, his slender build moving up and down the seats as he engages with his guests. His many regulars relish the opportunity to see the man with whom they've been talking and tasting tequila for so many years.

San Francisco has become the leading market of tequila in America. Bay Area residents are among the most educated about all agave-based spirits, mezcal included. The cultural ties to Mexico, the history, the tradition, the connection to agriculture and terroir, the access to Bermejo himself, the number of bars now with exemplary selections and the intellectual curiosity of the people who live here work in concert to create savvy, appreciative consumers.

"Tommy's is such a huge influence around the world," says Fitzgerald. "It's so iconic and such an important thing for the West Coast." Thanks to Bermejo, the rest of the world now knows the beauty and virtues of 100 percent blue agave tequila.

The influence of these four men is significant. They were industry leaders who set the stage for cocktail renaissance in San Francisco and made proper drinks fashionable again. Harrington's interest in classic cocktails, penchant for Mojitos and book, *Drinks Bible for the 21st Century*, was a gateway for others. His recipes, prose and photographs captured the attention of eager bartenders near and far. Dionysos made both history and bartending look cool with his smooth performance and ability to school anyone with his deep knowledge of cocktail history. Vogler's reverence of simple ingredients drew on the work of Alice Waters and allowed him to stand up for his belief in carrying products made with transparency and integrity. Bermejo's love for 100 percent agave spirits was infectious and awoke countless people, bartenders and regular patrons alike, to the virtues of quality tequila.

They also made it more socially acceptable to choose bartending as a career. As their drinks became one of the most cherished parts of the dining experience, they garnered respect from restaurant owners, restaurant critics and the general public. Their work paved the way for bartenders who followed to pick up and change cocktail culture forever.

A GROWING COMMUNITY

By the early 2000s, San Francisco had earned a solid reputation for being the best cocktail city on the western seaboard. Much of the city's bar culture emerged from restaurants. As they strove to get people to value cocktails the way they did food and wine, bartenders benefited from their access to kitchens and proximity to chefs. In turn, restaurant bar programs were elevated.

Out of these restaurant bar programs came a second wave of new bartenders, all of whom stood on the shoulders of Paul Harrington, Marcovaldo Dionysos, Thad Vogler and Julio Bermejo. The work of this cohort of blossoming bartenders—Erik Adkins, David Nepove, Jacques Bezuidenhout and Scott Beattie—dovetailed with their predecessors. Together, they helped develop a higher standard for bars around the Bay Area, creating a new canon for the burgeoning cocktail revival. At the same time in the Bay Area, tiki was making a comeback, a subculture that was born in California during the 1930s. It had previously run parallel to cocktail culture, but tiki began to intertwine with the cocktail renaissance in the early 2000s. The innovations that came out of this period further cemented the Bay Area's place in the modern cocktail revival and created an identity for West Coast cocktails, which was recognizable in their use of high-quality spirits and seasonal produce.

ERIK ADKINS

Erik Adkins' importance in the cocktail renaissance is hard to overstate. He is the embodiment of the intersection between exemplary hospitality and expertly crafted drinks. He sets the bar high for his staff and has earned an unparalleled reputation for being the best educator of novice bartenders around. He is undoubtedly one of the reasons that San Francisco has become one of the nation's leaders in cocktails.

Adkins came up under Thad Vogler, whom he almost matches in height. Akins stands several inches over six feet tall, making him a strong physical presence. He has a warm face that brightens whenever he smiles, which is often. He has welcoming blue eyes, making his stature less intimidating. Though I never had the opportunity to see Adkins and Vogler behind the bar together, their height matched their standards.

Adkins, now one of the Slanted Door Group's longest-running employees, got his start in the service industry in Southern California at his stepfather's diner. His first foray into bartending was at a bar inside a Nordstrom's department store when he moved to San Francisco after college. They needed Christmas help, and he needed money, fast. "The first day, I made seventy dollars in tips and thought it was some serious money," he remembers.

From there, he went on to work at Gordon Biersch and then Thirsty Bear, both of which are brewpubs. In 2000, he started bartending at Slow Club in the Mission district of San Francisco. They served cocktails, and he learned how to make them by using Paul Harrington's book, *The Drinks Bible for the 21st Century.* "His book was the only one they had there," Adkins recalls. He worked there for about a year, familiarizing himself with the basics of cocktails. He moved to the British Virgin Islands for a year but returned to San Francisco for more stability.

His life changed in 2002 when he was hired at the Slanted Door. The restaurant had just moved from its original location on Mission Street to Brannan Street, a space that had a full liquor license. Vogler was running the bar program and began training Adkins, imparting his ethos of viewing spirits as agricultural products. In the cocktail section of *The Slanted Door: Modern Vietnamese Food* cookbook, Adkins writes, "This is where I met Thad Vogler, who greatly shaped the Slanted Door's early bar program, and also my view of spirits and cocktails."

In addition to accepting Vogler's intolerance for mass-produced spirits from companies with big marketing budgets, Adkins learned how to develop his palate from Vogler. "Before I worked at the Slanted Door, I

Tiki bar waterfall installation. *Photo by Nando Alvarez-Perez and Vaughan Glidden. Courtesy of Pagan Idol.*

Tiki demigod. *Photo by Nando Alvarez-Perez and Vaughan Glidden. Courtesy of Pagan Idol.*

Left: Fresh fruit and whimsy. *Photo by Nando Alvarez-Perez and Vaughan Glidden. Courtesy of Pagan Idol.*

Below: An array of tiki drinks. *Photo by Nando Alvarez-Perez and Vaughan Glidden. Courtesy of Pagan Idol.*

Tiki cocktail. *Photo by Nando Alvarez-Perez and Vaughan Glidden. Courtesy of Pagan Idol.*

Rum. *Photo by Nando Alvarez-Perez and Vaughan Glidden. Courtesy of Pagan Idol.*

Tiki cocktail. *Photo by Nando Alvarez-Perez and Vaughan Glidden. Courtesy of Pagan Idol.*

Tommy's Margarita. *Photo by Nando Alvarez-Perez and Vaughan Glidden. Courtesy of Hamlet.*

Garnished glass. *Photo by Nando Alvarez-Perez and Vaughan Glidden. Courtesy of Ramen Shop.*

Manhattan. *Photo by Nando Alvarez-Perez and Vaughan Glidden. Courtesy of Ramen Shop.*

Above: Manhattan variation. *Photo by Nando Alvarez-Perez and Vaughan Glidden. Courtesy of Ramen Shop.*

Left: Cocktails, ready for consumption. *Photo by Nando Alvarez-Perez and Vaughan Glidden. Courtesy of Ramen Shop.*

Right: Botanicals. *Photo by Nando Alvarez-Perez and Vaughan Glidden.*

Below: Dried seasonal peppers to be used in homemade tinctures. *Photo by Nando Alvarez-Perez and Vaughan Glidden. Courtesy of Umami Mart.*

Tiki ingredients. *Photo by Nando Alvarez-Perez and Vaughan Glidden.*

Test runs at St. George Spirits. *Photo by Nando Alvarez-Perez and Vaughan Glidden. Courtesy of St. George Spirits.*

Test stills at St. George Spirits.
Photo by Nando Alvarez-Perez and Vaughan Glidden. Courtesy of St. George Spirits.

Whiskey, neat. *Photo by Nando Alvarez-Perez and Vaughan Glidden. Courtesy of St. George Spirits.*

Left: Pisco Sour, ready for sipping. *Photo by Nando Alvarez-Perez and Vaughan Glidden.*

Below: Strawberry Mojito. *Photo by Nando Alvarez-Perez and Vaughan Glidden. Courtesy of the Thirsty Vintage.*

Above: Fernet. *Photo by Nando Alvarez-Perez and Vaughan Glidden. Courtesy of Umami Mart.*

Right: Gin Martini with a twist. *Photo by Nando Alvarez-Perez and Vaughan Glidden.*

Right: Hemingway Daiquiri. *Photo by Nando Alvarez-Perez and Vaughan Glidden. Courtesy of the Thirsty Vintage.*

Below: Barware, vintage and new. *Photo by Nando Alvarez-Perez and Vaughan Glidden. Courtesy of Umami Mart and the Thirsty Vintage.*

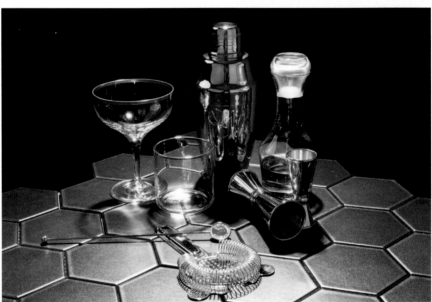

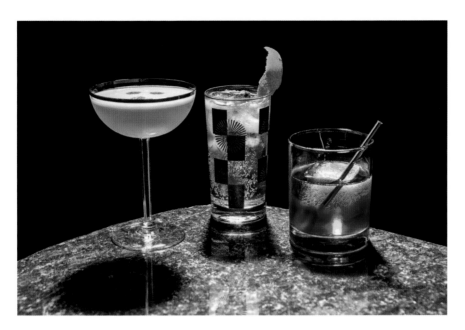

Cocktails, shaken and stirred. *Photo by Nando Alvarez-Perez and Vaughan Glidden. Courtesy of the Thirsty Vintage.*

House-made bitters. *Photo by Nando Alvarez-Perez and Vaughan Glidden.*

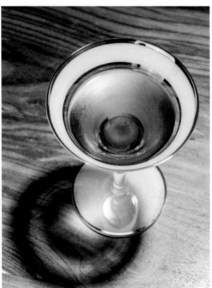

Above: Fresh citrus. *Photo by Nando Alvarez-Perez and Vaughan Glidden. Courtesy of the Thirsty Vintage.*

Left: Martinez. *Photo by Nando Alvarez-Perez and Vaughan Glidden. Courtesy of the Thirsty Vintage.*

Gin and tonic ingredients. *Photo by Nando Alvarez-Perez and Vaughan Glidden.*

An array of salts. *Photo by Nando Alvarez-Perez and Vaughan Glidden.*

Lance Winters in the lab at St. George Spirits in Alameda, California. *Photo by Jon Santer.*

Martin Cate at Smuggler's Cove in San Francisco, California. *Photo by Jon Santer.*

remember going to a bar and just being like, 'I want a Martini.' I had no idea what gin to order. I'd been bartending for a decade, and I had never tasted gins neat behind the bar. I ordered Bombay Sapphire because it was on a billboard. I remember thinking, 'That's got to be good, right?'" Vogler encouraged him to start tasting spirits behind the bar. They went through every spirit they stocked. "Suddenly," he says, "I have opinions based on what I thought it tasted like, not what a distributor told us or what I thought billboards meant." His point of view developed with his palate, helping him realize the importance of taste. "It's a skill set," he says. "If you're good at tasting, you can succeed, you can pick better wines and you can make and workshop better drinks." Adkins was able to build his career on this skill, something for which he is lauded by his colleagues. "There's nobody [on the West Coast] who makes better drinks than Erik Adkins, in my opinion," says bar owner Jon Santer.

Together, Adkins and Vogler honed the Slanted Door's level of service. They would play chess and talk after work, often about their collective concept for ideal hospitality. Because the Slanted Door carried specialized products that weren't as well known as big brands, like Bacardi, customers were often unfamiliar with their drink ingredients. Guest interactions would often require more conversation so questions about certain cocktails could be answered or explanations about why they didn't have Jameson could be given. To honor their principles for hospitality, they knew it was important to make guests feel welcome in a place where they couldn't fall back on the comforts of familiar big brand spirits. In order to make people feel welcome at the bar, Adkins and Vogler wanted to think carefully about how they were speaking with patrons. They decided to use selective language and were strategic about their word choice. Although they often had to say no to guests when they ordered a product that they didn't carry, they tried to make guests feel like the products they did have were hidden gems. "We want to make you feel like you've discovered this thing. If you feel like you discovered this cool cocktail or gruner veltliner as a varietal, it makes you feel special instead of us telling you that we don't have what you want. I think it's a way of approaching the guest that lets you do cool stuff," Adkins says.

They also employed language in subtle ways at the start of an interaction. "You might say to someone 'welcome' instead of 'hi, how are you?' because you're conveying that they are welcome instead of forcing them to talk to you," he says. "I think word choices like that are important." These little methods of creating a warm environment enabled the Slanted Door to become esteemed not only for the food and drink but also the service.

Over time, much of what they discussed formalized into their "31 Steps of Service," which was published in a 2014 piece by online magazine *7x7*. "Looking back," Adkins says, "it really all distills down to having manners. You're being a host." Since the article was published, their "31 Steps of Service" have been adopted by many local and national bar programs.

Adkins' attention to the nuances of hospitality garnered attention from young bartenders, who would watch him interact with customers to pick up on the finer points of his service. "He's so conscientious," says Jennifer Colliau, who worked with him at the Slanted Door. "His customer service is extraordinary." Chris Lane, bar manager of Ramen Shop in Oakland, worked with Adkins at Flora, also in Oakland, where Adkins was later consulting. "When you start with Erik, he will give you his Cliff's Notes on hospitality and service that he asks of all his staff," Lane says. "It is a rather lengthy list of the dos and don'ts. Really, what it comes down to is awareness and manners. For me, that describes part of why he is so good—he is a very aware person behind the bar and is polite to a fault. The only way I could get a better appreciation for it was to watch and listen. Every time I would work with him or sit at his bar, I would be cataloging how he talked to guests and how he adjusted himself with each person. Adaptability is maybe the aspect of bartending that I hear the least amount of talk regarding, and it is just so important. Erik has this very disarming manner about him that I think people do not expect because he is such a physically big person. In addition to that politeness, he is known for a super intuitive ability to read people quickly. It was absolutely inspiring to me to see him as a role model who embodied the high standards of craft he preached."

Adkins took over the bar program from Vogler in 2004 when he moved to Guatemala to work for a nonprofit. That was also around the time that the Slanted Door relocated for a third time. It moved to the Ferry Building on the Embarcadero and became an instant hit with locals and tourists alike. People came for the food and the view of the San Francisco Bay, while the cocktail program continued to be one of the main draws. Adkins continued to dig into his cocktail education and spent time workshopping drinks with his staff.

In fact, Adkins patience for trying as many iterations of drinks with his staff allowed him to continue to elevate the reputation of cocktails in the Bay Area. It also caught the attention of many up-and-coming bartenders around town who wanted to work for him. When Adkins opened up Heaven's Dog for the Slanted Door Group in January 2009, he had a bar team composed of many rising stars. "Our opening team was our Camelot. It was the first time

Erik Adkins at Prizefighter in Emeryville, California. *Photo by Jon Santer.*

I heard the words 'bar stars' thrown around," Adkins says. They modeled the cocktail menu after Charles H. Baker's book *The Gentleman's Companion*, part travel log, part global recipe book. "There's something romantic about the Baker book, probably because the world changed forever after that time, after World War II," Adkins says. Leading up to the bar's opening, the staff would assemble and make twenty versions of a single recipe and discuss it until they could agree on the best specifications. "We had a good work ethic back then," he says. "Adkins is such a machine," says Scott Baird, owner of Trick Dog. "He's so precise. If I can't get a drink right in four times, I give up. Adkins will try thirty times." The Heaven's Dog menu became a favorite around town, due in equal part to the quality of the cocktails, the reputation of the bar team and the level of service.

Adkins' precision is a source of wonderment for young bartenders who train under him. When Lane was working with him, he tried to emulate everything that Adkins did. "He leads by example, and I don't think I have ever seen him half ass a drink. If he has an outcome that he doesn't deem fit, he starts over. Learning the way he makes drinks can be really frustrating because he is always adjusting his variables on the day. He makes the drink to spec, and then he will nudge the measurements where he needs them

to be. I remember tasting [one of] his drinks and then making it exactly how he made it. I did not miss a single step or measurement and shook the hell out of it just like he did. My drink was nowhere [near] as good. I asked him why, and he just kind of shrugged and said, 'I don't know.' [He gave me] this little 'I know something you don't know' smile. Of course, now that I have done this for a bit and had similar questions asked to me by younger bartenders, the reality is clear of why his drinks always taste better—he's just an incredibly gifted craftsperson. We have all tried to figure out why his drinks taste better, but I think that is why he is so revered by other bartenders. He has all these little x factors that really can't be taught. As one of his bartenders, you really feel this genuine love for what he does, and for me it was inspirational," says Lane.

Heaven's Dog closed in 2012 after the building flooded. Adkins went on to open multiple bars for Phan, including Wo Hing General Store, the Coachman and Hard Water. Several female leaders of the industry came up at those bars under him, including Jennifer Colliau, Jackie Patterson and Brooke Arthur. Colliau worked at the Slanted Door before moving to Hard Water and, later, Heaven's Dog. Adkins, who had become a leader in the bar community, welcomed Colliau to come to events with him. Often, she was the only female who attended these events. Through her friendship with Adkins, she was able to build her own network and is now an industry leader in her own right. She founded a pre-Prohibition-era syrup and ingredient company, Small Hand Foods, while working for Adkins. He and Vogler were among the first people to carry her products, helping her company grow into a success.

In addition to his work for the Slanted Door Group, Adkins took on a few consulting jobs in the East Bay. He opened Flora, a restaurant in downtown Oakland (where he first worked with Chris Lane). He also consulted on Bull Valley Roadhouse, a restaurant in Port Costa that is now popular for its guest bartender events. In these roles, he brought his ideology to the bar community across the Bay, which wasn't yet as saturated as San Francisco. Many young bartenders learned from him, as their counterparts across the bridge had. Adkins' programs added to the handful of quality bars that existed in Berkeley and Oakland, helping the East Bay to become a cocktail destination in its own right. "Back then, if you did something decent in the East Bay it would be successful, but that ship sailed a long time ago. You have to do good things now," he says.

It is through Adkins' tireless devotion to precision, talent for making his guests feel welcome, deep interest in thorough staff trainings and desire to

carry quality products at his bars—like Thad Vogler taught him to do—that he has become one of the Bay Area's most important industry leaders. His efforts at the Slanted Door Group's bars warmed people to the idea of better cocktails, raising the bar for bartenders and patrons alike.

DAVID NEPOVE

Over in North Beach, Enrico's Sidewalk Café—where Paul Harrington kicked off the age of the Mojito—became a hub for blossoming bartenders. These were the days when Marco Dionysos was there for the second time and had gained a following after opening Absinthe. One of Dionysos' fellow bartenders was David Nepove. Nepove, who became serious about bartending while at Enrico's, after working with Dionysos, embraced the Mojito craze and would later put his own spin on the trend. His name is now more synonymous with this drink than Harrington's, evident in his moniker as Mr. Mojito.

Nepove is a tall, strapping man whose accent sounds more like he is from a suburb of New York City than his native Southern California. Though he had been working in restaurants since he was a teenager, he started tending bar in Los Angeles while he was in college. His early exposure to cocktails was at the Santa Monica restaurant Carlo's and Pepe's, where he made countless Margaritas with fresh lime juice (a rarity in the late 1980s).

Looking for a change, he moved to San Francisco in 1994. He landed a gig at Splendido's on the Embarcadero, where he was trained by Adam Ritchie. "That's where I truly learned about fresh juices," he says. From there, he had short stays at Vertigo and Shanghai 1830. In 1996, he reconnected with Ritchie. By then, Ritchie was the lead bartender at Enrico's, and Nepove ran into him while having lunch there. Ritchie, who liked Nepove, asked him if he wanted to pick up a few shifts. Nepove was trying to pay off some debt so he could travel across the United States, and he accepted Ritchie's offer. He worked there for a year, learning from the old guard of bartenders like Big Ward Dunam while he paid off his debt. In early 1997, when he had met his financial goals, he left Enrico's and set off on his road trip. He traveled across the country and spent a few months in New York. There, he tended bar and replenished his bank account. Later that year, with a full wallet and his goal to see the country achieved, he returned to San Francisco. He returned to Enrico's, where he easily got back his job.

When he rejoined Enrico's team, he got serious about bartending. He cites this as a turning point, one that changed his life. This was in large part because of Enrico's, where Mojitos were all the rage. "When I came back, it was right where it left off," he says. "It was incredibly busy, the dotcom [boom] is going on, the patio is packed, the weather was beautiful and we're selling hundreds of Mojitos. We went through so much mint it was ridiculous. I spent years explaining to people what a Mojito was, saying, 'Mint, lime, sugar, rum and soda.' 'Mosquito?' 'No, it's a Mojito.'"

Paul Harrington's original cocktail program was holding strong, and Enrico's bartenders were carrying his torch. "Harrington's book was our bible," says Nepove. This meant they were making classic cocktails in addition to Mojitos. It forced Nepove to learn the fundamentals of these drinks. "I wouldn't say that we were studying classic cocktails—that came later—but the fact that we had classic cocktails, the fact that we had maraschino in 1996, the menu was Paul," Nepove says.

Marco Dionysos helped keep Harrington's spirit alive with his interest in classic cocktails. Most people in the industry knew that Dionysos was the king of cocktail history, which was sometimes polarizing because of his quick wit and sharp tongue. He and Nepove didn't immediately hit it off, but after working together for a bit, they became good friends. Nepove thinks of himself as a sponge and likes to surround himself with smart people. And he learned the most from Dionysos, including the finer points of technique. "We used to cut our twists and put them in a garnish tray like most bars did back then," Nepove says. "Marco would have a fruit bowl next to his well at the bar. I asked him, 'Why are you doing that when you have a twist right here?' He had to show me the difference [in the oil fresh twists produced]. Most bartenders learn from the person to the left and to the right, [most of whom] had no training at all. I was very lucky to have Marco to my right. He was the person who taught me things that nobody else did. He inspired me to ask more questions and do research. While I'm a great bartender because of my personality, I'm a better bartender because of what I learned from Marco."

Nepove eventually became the bar manager in 2000, which was around the time he began to think about seasonality. He wanted to incorporate the diverse produce for which the Bay Area was known, so he got creative with different types of fresh fruit. One day, a fellow bartender brought in a kumquat, which piqued his interest. He muddled it into a Mojito and realized there was a lot of potential for new flavor combinations. This evolved into the Kumquat Caipiroska, a simple drink that earned Nepove

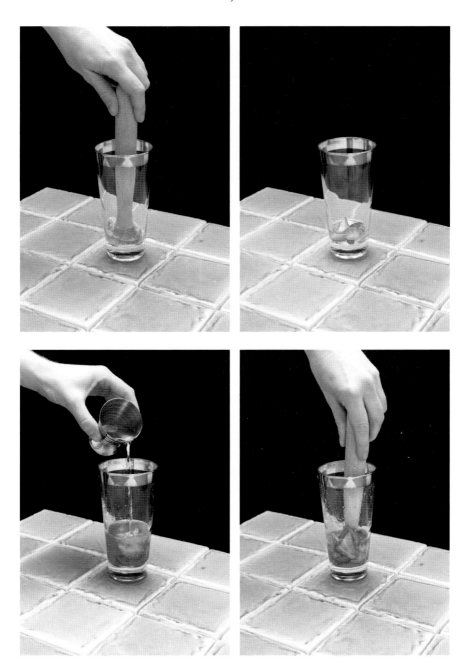

Clockwise from top left: Muddling sugar and water for a Strawberry Mojito; adding strawberries, ready to be muddled; muddling strawberries for the Mojito; adding white rum to the Mojito. *Photos by Nando Alvarez-Perez and Vaughan Glidden. Courtesy of the Thirsty Vintage.*

a lot of press. He started experimenting with variations of Mojitos, which became a hit. He put a Mojito section on Enrico's menu. "I became the guy who loved using fresh fruit and muddling everything up. I started bringing in flats of strawberries, raspberries and kiwis and putting whole watermelons on the bar. People loved it because they got to watch all this fresh fruit get incorporated into cocktails. They loved watching the drinks being crafted with all of these fresh ingredients. If they were happy, I kept trying new things," he says.

Up until this point, Nepove had personally preferred Manhattans to Mojitos. "I drank Manhattans," he says. "My first e-mail address was 'Mr. Manhattan.'" Gradually, his identity shifted. He was always happy to make a Mojito and never said no to muddling, which earned him the nickname Mr. Mojito. "I remember walking down the street and somebody saying, 'You work at Enrico's, right? You make Mojitos, right?' I'm like, 'Yeah, that's me. I'm Mr. Mojito.' It's almost like it just popped out of my mouth as a joke. I retired Mr. Manhattan when I became Mr. Mojito."

Because he was muddling so much, Nepove started to notice design flaws in the red muddlers that were ubiquitous in Bay Area bars. "David realized that the muddlers he was using at some point looked like all the paint had flaked off," Dionysos says. They were small and easily grew mold. Together, he and Dionysos designed a new type of muddler that was wooden, unpainted and long enough to fit in a pint glass without causing a hand cramp. "They were pretty simple at first," Dionysos says. Thus, Nepove's side business was born, appropriately called Mr. Mojito. "At one point he was getting orders for forty thousand muddlers at a time from Moet-Hennessey," Dionysos remembers. Nepove still runs this business and has added a few new products over time, including food-safe plastic muddlers, jiggers, spoons and strainers.

Nepove received a lot of positive press for his work at Enrico's. Much of this media attention focused on his Mojito variations, which drew tourists. His use of fresh fruit and attention to seasonality contributed to the identity of the West Coast cocktail, which people associate with bright, juicy drinks over brown, spirit-forward libations. He stayed at Enrico's until 2006. It closed the following year after complications with the lease renegotiation. From there, he took a job with Southern Wine and Spirits as the director of mixology. He now consults on bar programs and trains novice bartenders on proper mechanics, the virtues of fresh ingredients and product knowledge. As we'll see, he formed strong ties with the bar community and helped professionalize the industry as part of the National United States Bartenders' Guild.

Jacques Bezuidenhout

If you pull up a bar seat at any good cocktail bar in the Bay Area, you will usually find a dynamic selection of cocktails that use boutique liqueurs and often involve tequila. You have Jacques Bezuidenhout to thank, in part, for this. He made innovative drinks accessible to Bay Area drinkers, along with tequila, thanks to his friendship with Julio Bermejo. He became steeped in the industry, he took cues from Bermejo and Marco Dionysos and he created a style all his own.

Bezuidenhout, who hails from South Africa, came to San Francisco in 1998. He had been bartending in London previously, where he worked in pubs and restaurants. He first learned about cocktails while working at the Avenue in London, where the law required all alcohol to be measured by a jigger under the British Weights and Measures Act. He had always had a fascination with the United States, however, and wanted to give working in America a try. After traveling around the United States on a Greyhound bus, he landed in San Francisco. "San Francisco had an effect on me," he says. "There was something about it that felt small and European, and you could navigate it really easily." He chose to make it his home and became steeped in the industry.

His first job in San Francisco was at the Irish Bank, a pub in the Financial District, where he worked for six years. "I was just looking for bar work," he says. He had become interested in scotch while in London and took the opportunity to grow the Irish Bank's selection of single malt. He enjoyed the history of the spirit and liked to share its story with guests. This became a draw for customers. "Single malt then was the whiskey of choice, not American whiskey," he says. His curation of scotch served as a gateway to the larger bar community. It garnered attention from other bartenders, like Dionysos. Gradually, they started popping into the Irish Bank. In turn, Bezuidenhout would go see them at their bars. He had a wide breadth of knowledge, a good palate and European bar experience, which contributed a lot to the community in the early days of the cocktail revival.

In his conversations with his new industry friends, he heard about Tommy's Mexican Restaurant repeatedly. People kept talking about Julio Bermejo and his tequila selection. Bezuidenhout decided to check it out for himself, an experience that would prove formative. "I think it was probably 1999 when I first went. I wasn't a tequila drinker at all, coming from South Africa," he says. He caught Bermejo behind the bar. True to form, Bermejo immediately introduced himself as he carried on

conversations with his regulars. Bezuidenhout was impressed that Bermejo seemed to know everyone's name. "Two weeks later, we went back. In typical Julio style, the place is two deep, but he looked up at me and says, 'Oh hey, Jacques, how are you?'" he says. "After that, we started becoming friends. He and Tommy's are among my biggest influences."

Bezuidenhout was surprised by the diversity of flavor and the history of agave. He undertook Tommy's Tequila Master's program to further his education and traveled to Mexico numerous times with Bermejo. For Bezuidenhout, tequila was about enjoying a spirit emblematic of geography, history and culture across all sociocultural boundaries. He was also interested in Bermejo's use of freshly squeezed limes. While fresh juice is commonplace in bars now, it was few and far between before the cocktail revival took off a few years later. He began implementing fresh juice into the Irish Bank's program. "After seeing Tommy's, we were like, 'All right, from now on we are going to cut our limes in half. Instead of using the bottle of sweet and sour, we're going to squeeze fresh Margaritas here,'" he recalls.

As he expanded his knowledge of spirits, his desire to learn more about cocktails also grew. "I would always order strange liqueurs, and the other bartenders would roll their eyes at me," he says. After six years at the Irish Bank, he left in 2004. "I was looking for an opportunity to make more cocktails," he says. His interest in cocktails is what ultimately led to his departure from the Irish Bank in 2004. He became a brand ambassador for Plymouth Gin. Brand ambassadors were new positions then, and the role was a bit of an enigma to him initially. But it was an opportunity to work with their London-based international brand ambassador, Simon Ford. It also meant learning more about gin, traveling and working on other bar projects where cocktails were more of a focus.

One such project was Tres Agaves, the bar that Julio Bermejo opened in 2005. Bermejo appointed Bezuidenhout the bar manager. He was excited for the opportunity to work more with tequila and be more creative. "We had fun digging into what fruits and herbs we could get from the kitchen and pair with just tequila," he says. "It was playing around with everything we had access to and getting people to drink outside of their comfort zones."

When Tres Agaves opened, people had trouble recognizing many of its products because they weren't mass produced or widely available. They carried tequila made with 100 percent agave, something still relatively obscure in bars around town. "It was a bit of a brand battle," Bezuidenhout says. To get people to drink these unfamiliar tequilas, he took an educational approach. "We tried to tell the story of tequila through tasting." He hoped

the narrative would invite interest in brands that weren't mass marketed, much like what Bermejo had done for him years earlier at Tommy's. Bezuidenhout also employed the use of fresh fruit, a trend that was tried and true in the Bay Area. It was through this menu that he was able to showcase the strength of his palate. His creativity earned him a strong reputation among his peers. "Jacques' cocktails were innovative," says Ryan Fitzgerald, one of the bartenders at Tres Agaves. Similarly, David Nepove admired how progressive the menu was. "Jacques was doing sherry cocktails before sherry was cool," Nepove says.

In 2006, a year into Tres Agaves, Bezuidenhout began to work part time for Partida Tequila as a brand ambassador. He was the single brand ambassador for the entire United States, which meant a lot of travel. Eventually, he left Tres Agaves and took a job with Kimpton Hotels, where he focused his energy on building bar programs. He helped open new bars at their hotels around the country. He did this for six years before growing tired of spending time on the road. He wanted to stay closer to home and focus on his own projects. Indeed, in 2014, he partnered with Kenny Luciano and the Plumpjack Group to open his own bar, the Forgery, in San Francisco, where he was able to use the skills and knowledge he had acquired over his sixteen years in the U.S. industry. In 2016, he opened a second bar, Wild Hawk, also in San Francisco. He has become one of the most respected leaders in the industry and has left his mark all over the country, and as we'll see, he became a cornerstone of the Bay Area bar community.

Scott Beattie

Scott Beattie helped put the Bay Area on the map in the mid-aughts. He contributed to the West Coast cocktail's identity by using foraged ingredients, homemade syrups and brightly colored garnishes that enhance the glass. His drinks garnered a lot of media attention, helping people catch on to the innovation that was happening with cocktails, something that proved as fun as it was photo worthy. Beattie is a native San Franciscan who grew up around the agricultural diversity that helps define the Bay Area. He started bartending in 1996, when cocktails were a far cry from what they are today. He worked at a place that carried artificial mixers, and as he wrote in his book *Artisanal Cocktails*, published in 2008, the drinks were "oversized, full of sugar, high in alcohol content, and far from what I would consider a quality beverage."

His life changed when he sat at Marco Dionysos' bar at Absinthe roughly two years into his bartending career. The cocktails Dionysos made Beattie allowed him to see the impact that quality ingredients have on drinks. Well-sourced and well-made products just make cocktails taste better. One of these cocktails was Dionysos' Ginger Rogers, which Beattie cites as his gateway cocktail. Its flavors were unlike anything he had tasted. This experience inspired him to take a more culinary approach to his craft.

Beattie started using this approach when he moved to Napa Valley and began running the bar at the Martini House in St. Helena. He worked alongside Chef Todd Humphries, who had a penchant for incorporating foraged ingredients into his dishes. It wasn't long until Beattie began foraging himself. He started in his father's nearby garden and expanded into the local neighborhoods. He read books on cocktail history. He consulted *The Flavor Bible* to understand flavor pairing and talked frequently with the kitchen team. He experimented with spices, herbs and seasonal fruits at home.

In 2005, he joined the team at Cyrus, a new restaurant in Healdsburg, as the bar manager. He had met their chef, Douglas Keane, while working at Martini House. Keane and his maître'd, Nick Peyton, liked Beattie's work and recruited him to be part of their opening team. Cyrus allowed him the freedom to integrate his home experiments at the restaurant. He dove further into spirit research and opted for products made with integrity. He stocked locally made spirits from the St. George Spirits and Charbay distilleries. Cyrus was known for its thoughtful, well-executed menu, and Beattie wanted the drink menu to match the quality of the food. He made his own syrups and used exotic herbs and spices. Fresh juice was a staple in his program. The kitchen allowed him space to play around with foams and dehydrated fruits. It wasn't difficult for him to conjure ideas. "It's easy to be inspired with so many high quality, local ingredients bursting from the earth," he wrote in his book.

After reading Bay Area–based chef Daniel Patterson's book *Aroma: The Magic of Essential Oils in Foods and Fragrance*, Beattie reached out to Patterson to discuss correlations between food and drink. The two began to meet regularly for coffee to talk about how to incorporate essential oils into cocktails, helping him deepen his culinary approach. He also read Michael Pollan's *The Omnivore's Dilemma*. "That book was very influential and made me think about where food comes from and how it got to the table," Beattie says. "It helped me to put a face on ingredients. I was borrowing ideas and techniques from chefs and using Alice Waters' philosophy [of privileging

locally grown and unprocessed seasonal foods]. There's deliciousness to be had if you put some thought into it."

Beattie's work paid off, and the bar at Cyrus became a popular destination. Not only did his drinks taste great, but he also made them visually stimulating with his lavish garnishes of flowers, fruits and leaves. Because he was incorporating so much from the kitchen, his drinks were hard to reproduce. He was one of the first people to be called a "bar chef." This caught the eye of the local media, which began running stories about the bar at Cyrus. He became one of the first bartenders to be treated with the same celebrity status that chefs were now enjoying. This attention attracted Ten Speed Press, a publisher based in the East Bay. He got a book deal, which was filled with brilliant glamour shots of his camera-friendly drinks. The book, *Artisanal Cocktails*, earned him national acclaim, carving a space for West Coast cocktails in the international conversation about cocktails. He motivated bartenders around the country to start experimenting with what was in their backyards.

Though Cyrus is now closed, Beattie continues to work in Napa Valley. He runs the cocktail program at the Meadowood Inn, a James Beard Award–nominated restaurant and hotel. He continues to stay active in the Bay Area bar community as well, often speaking at related events. He works with the Center for Urban Education about Sustainable Agriculture (CUESA), which runs weekly farmers' markets at the Ferry Building in San Francisco, on its seasonal cocktail events, where he continues to share his culinary approach to drinks with others.

Adkins, Nepove, Bezuidenhout and Beattie furthered the reputation of Bay Area cocktails. These men worked with their predecessors—Paul Harrington, Marco Dionysos, Thad Vogler and Julio Bermejo—to create a canon for proper cocktails. Now, if bartenders wanted to be taken seriously, they needed to engage with drinks in a more thoughtful way. As the elevation of bar programs went from vodka sodas to muddled Strawberry Mojitos, it was expected for a bar to squeeze fresh juice, make its own syrups, use seasonal produce and experiment with tinctures. It was also expected that drinks were consistent and service was efficient. As innovative ingredients made their way to more and more menus, bartenders encouraged guests to drink better drinks.



THE INTERSECTION OF TIKI AND CRAFT

California is the birthplace of tiki, which, like cocktails, is a uniquely American thing. "There's nothing else like it. It's so weird. It doesn't make any sense. It's one of these only-in-America things. It could have only happened here," says Martin Cate, owner of Smuggler's Cove. In 1933, America's first tiki bar, Don's Beachcomber Café, opened in Hollywood, California. Ernest Gantt, the founder of the bar, birthed a subculture that swept the nation and continues to draw ardent enthusiasts. As Martin and Rebecca Cate write in their book, *Smuggler's Cove: Exotic Cocktails, Rum, and the Cult of Tiki*, the opening of Don's Beachcomber Café "changed the course of American cocktail culture, dining, and design for the next forty years." Shortly after, what would become the country's second tiki bar opened in Oakland, California. In 1934, Victor Jules Bergeron opened a place called Hinky Dinks on San Pablo Avenue, where he served modest cocktails. One of his rum drinks, the Banana Cow, became a favorite. In an effort to up his game, Bergeron traveled to New Orleans, Havana and Hollywood, where he stopped at Don the Beachcomber's (now in a new location with a slightly different name). Bergeron's time at Gantt's tropical oasis inspired him to revamp Hinky Dinks. When he returned to Oakland, he transformed the bar into a tiki den and changed its name to Trader Vic's in 1937. Thus, the Bay Area's most famous tiki bar was born. This is where the Mai Tai was invented, a drink now famous in the tiki canon.

Tiki was originally inspired by Polynesian culture and artistry and the flavors of the Caribbean. It is a type of escapism that allows patrons to enter a world defined by its exotic drinks, whimsical design and tropical music. It became very popular in America, especially during the postwar years (Trader Vic's San Francisco experienced its heyday from the 1960s through the 1980s). "I think tiki is a really important part of the history of American drinking," says Martin Cate. "It's the biggest, longest-lasting fad in American drinking history. It was four decades during its prime. It's not like Mojitos in the 1990s or fern bar drinks in the 1970s. I'm talking about a forty-year drink phenomenon in American history. That shouldn't be swept under the rug."

In its prime, Trader Vic's was one of the hottest places in town. Herb Caen, a writer for the *San Francisco Chronicle*, ran a story about the original Oakland location in which he said, "The best restaurant in San Francisco is in Oakland." At the San Francisco location, celebrities and local politicians including Danielle Steel, Mayor Willie Brown and Diane Feinstein all had

regular tables. Eventually, the popularity of tiki began to fade in the 1990s, leading to Trader Vic's closure in 1994. However, it began to make a comeback with the burgeoning cocktail renaissance in the early aughts.

Tiki drinks often use a combination of rums that create layered, complex flavors not typically found in classic cocktails. Yet tiki drinks and classic cocktails both incorporate fresh juice and syrups that need to be carefully measured to achieve a proper balance. Spirits and liqueurs used in these drinks had become difficult to find on the mainstream market after tiki declined in the 1990s. The limited availability paralleled the more obscure ingredients used in classic cocktails, which were also hard to find after they dipped in popularity. When people started to become interested in cocktails

Mai Tai. *Photo by Nando Alvarez-Perez and Vaughan Glidden. Courtesy of Pagan Idol.*

again, they started asking their local liquor stores for particular products. In San Francisco, Dominic Venegas was working as the spirits buyer for the long-standing liquor store John Walker's. Venegas was also a bartender who was interested in classic cocktails, so he made an effort to import obscure products. Cate, who was setting up a home tiki bar at the time, would visit Venegas and ask about certain ingredients. He inquired about falernum, a liqueur commonly used in tiki drinks. "I remember his eyes lighting up when I asked for it," says Cate. "He said, 'No, what's that? What's falernum?' 'It's this liqueur from Barbados.' He's like, 'I've never heard of that! How do you spell that?' He would write it down and find an importer. That was just so exemplary of what was happening at that time because everybody really wanted to discover new things, like what other ingredients they could find or what other old cocktail recipe books they could uncover."

The interest in historic ingredients and craft made tiki and the cocktail renaissance dovetail. Tiki is now commonly thought of as part of the cocktail canon. Cate opened Forbidden Island in 2006 and Smuggler's Cove in 2009, putting tiki back on the map. Bartenders all over the Bay Area became interested in the intersection of classic cocktails and tiki

because the latter introduced them to new flavors and techniques. Tiki is an important part of the cocktail renaissance not just in the Bay Area but also all over the globe.

HIGHER STANDARDS, BETTER DRINKS

Now that there was an emerging standard for making proper drinks, increasingly innovative cocktails and more attention to hospitality, the goals of bartenders began to shift. Armed with confidence in their abilities and excitement for the craft, bartenders turned their attention to finding more obscure products that were in classic cocktail recipes.* This started in a basic way, with bartenders turning to less popular spirits like gin. At the time, vodka was at its peak popularity, though classic cocktail recipes didn't often call for it. Vodka was familiar and didn't require guests to drink outside their comfort zones. The problem with vodka, as many bartenders will tell you, is that it is tasteless, odorless and colorless. In other words, it doesn't impart much flavor on a drink. Essentially, it is a vehicle for other ingredients.

Many bar patrons refused to drink a classic cocktail made with gin. They remembered the intense piney flavor from the poor-quality gins of their youth. This upset many of the bartenders who were working hard to make drinks that were more complex and flavorful. "When I first realized the promise of gin as an alternative to vodka in a cocktail, I was sold, hook, line and sinker," says Jonny Raglin, partner in the Comstock Saloon. This created an industry-wide backlash against vodka. "Everybody at that time who cared about bartending hated vodka," says David Nepove. Raglin adds, "They didn't really know what they want, but it's a fear of this thing."

Some bartenders would encourage guests to try these better-quality gins neat to help change their mindset. "It's the thing that everybody feels like they hate," says Jessica Maria, owner of the Hotsy Totsy in Albany, California. "People were like, 'I hate gin. Make me anything but just don't put gin in it.' It became kind of my thing that I wanted to teach people about, that it can be your friend. I just want to wrap people's head around

* Many of the products that are staples in bars today—like green and yellow Chartreuse, over proof and agricole rum and liqueurs like Creme de Violette and Strega—were not available until Eric Seed began importing them in the mid-aughts around the time they were being reintroduced in classic cocktails.

In the lab at St. George Spirits. *Photo by Nando Alvarez-Perez and Vaughan Glidden. Courtesy of St. George Spirits.*

it. There are so many different styles. I would make people a cocktail with vodka and then with gin and would ask them, 'Don't you see how much the gin elevates that cocktail?' It's bringing out these different flavor components." Others would serve gin to guests who thought it was vodka because they didn't know the difference. A few bartenders took a more assertive approach to their disdain for vodka. "I think it got a little snobby saying no," Nepove says. "I was saying, 'Really, you want vodka? Let me make you a great gin cocktail.' But I was never a bad guy; it was more about letting me help you have a better experience." Alternatively, others realized they should employ their skills in hospitality to get people to try new drinks. This is in part why Thad Vogler and Erik Adkins developed their "31 Steps of Service" and realized that word choice matters when people don't have the comfort of a brand on which to default.

Many bartenders chose to balance their menus with easy, comfortable cocktails and other drinks that gently pushed the envelope. The Slanted Door's menu included a Basil Gimlet, which put a slight twist on a classic, familiar cocktail. Nepove started using different types of fruit in Mojitos, showcasing seasonality in an incredibly popular drink. Martinezes were made with higher-quality ingredients made from local sources, like St. George Spirits.

It was a slow burn, but bartenders did not give up. There were enough guests who were open to new things to keep bartenders excited. Cocktails were becoming more popular across the city and proved to be profitable, so restaurant owners allowed their staff to keep innovating. Their persistence paid off, and people began to notice that the best bars in town demanded their guests have higher standards for cocktails. Food writers began to notice the shifting drink canon and began to feature more bartenders in their reviews. Drink-based blogs became popular, particularly for cocktail enthusiasts who enjoyed making drinks at home or checking out new bars around town. This growth allowed the bar community to grow, which accelerated the cocktail revival.

THE RISE OF THE BAR STAR

COCKTAILING IN THE INFORMATION AGE

The cocktail renaissance grew with the rise of the Information Age. It served to both connect people and change the way that people expanded their knowledge. In the 1970s and '80s, leading up to the early days of the cocktail revival, there was no easy access to the Internet. It was not a tool that was used by the four men who effectively kicked off the cocktail renaissance—Paul Harrington, Marco Dionysos, Thad Vogler and Julio Bermejo—when they were getting their start in the Bay Area.

Prior to the ubiquity of the Internet, the Bay Area bartending community was fractured. It left many feeling like there wasn't much of a community at all. "There weren't many of us then," says Scott Baird, owner of Trick Dog. Bartenders often worked in silos, with friendships dictated by geography. Good rapport among industry professionals was more common if they worked in the same neighborhood. North Beach was a center for a small group of bartenders since the 1990s, and the Mission district connected dive bartenders, as did large restaurant companies that employed large staffs. But that was more or less it.

Around this time, people were getting their Bay Area restaurant news from newspapers and magazines and by word of mouth. This enabled food critics to become all-powerful, with the ability to make or break a business with their reviews, especially in San Francisco. Relationships with the media were important to industry professionals. Many knew their esteem with the media needed to be cultivated and maintained.

Everything changed in the early 2000s. With the rise of the Internet came more access to information, including about cocktails. The Bay Area includes Silicon Valley, ground zero for the technological innovation. As digital technology became omnipresent, it directly affected the bar industry. The Internet became a vehicle for connecting bartenders, helping them form professional networks and creating collegial bonds. It pushed them to ask for more information on cocktail history, drink recipes, culinary techniques and spirit production. Out of this came the San Francisco chapter of the United States Bartenders' Guild. It firmly planted roots for the local bar community, which is now one of the strongest in the nation.

It also helped cocktail writing develop. The Internet became a forum for people to talk about drinks and gave way to an active blogging community for cocktail enthusiasts. The cocktail revival became multi-vocal, challenging the authority of the restaurant critic. It bridged the gap between bartender and guest. Savvy consumers pushed bartenders to keep educating themselves. In turn, this further pushed the boundaries of the profession. Together, these forces changed the industry, shaping much of it into what it is today.

The United States Bartenders' Guild

The United States Bartenders' Guild (USBG) was one of the forces that brought the industry together. It was a formative moment in San Francisco's cocktail legacy, one that allowed people to become a unified front and raise the bar for quality of drinks. "At a time when bartending was becoming much more respectable, and energy was growing, the USBG was the magnet that pulled us all together," says David Nepove. "We reached more corners. We reached more individuals. We made it more available."

The formation of the San Francisco chapter of the USBG in 2002 came at the beginning of the Information Age in the Bay Area cocktail industry. Today, the National USBG has over fifty chapters around the country, with more starting all the time. It functions as a networking and educational resource for bartenders, industry members and cocktail enthusiasts. While the USBG has seen a few different iterations over time, its earliest membership was limited to no more than one hundred members. But by the late 1990s, its national reach had diminished. There was one chapter in California. "The Bartenders' Guild used to be everywhere," explains Marco Dionysos. "It had shrunk down to the point where it was just a small group of old men

in Southern California that got together once a month to play golf. Every time there was an international competition, they would Ro Sham Bo or something to select somebody to go represent the United States." Nepove, who is a self-proclaimed USBG historian, has membership magazines dating back to the 1950s and knows the story to be different. "They actually had cocktail competitions to determine the national winner, who then went to represent the USBG in the World Cocktail Competition," he posits.

Some of the bartenders who worked in North Beach, those who took cocktails seriously, banded together. "North Beach was the hub of cocktails," says Jacques Bezuidenhout. This group mainly consisted of Dionysos, Bezuidenhout, David Nepove and Todd Smith, a restaurant professional with a growing interest in proper drinks. At the time, Dionysos and Nepove were working at Enrico's, Bezuidenhout was at the Irish Bank and Smith was the floor manager of Glow, which was a restaurant across the street from Enrico's. He opened Glow with Jon Santer, who joined the North Beach fold. Santer, then a green bartender, would go to Enrico's to watch the bartenders work. "These guys were really good at what they did, and I wasn't, so I wanted to be good at it," Santer says. "At least passable, and I totally wasn't at first. No mechanics." Eventually, Santer started to hang out with them after their shifts, and the seriousness with which they took their jobs left an impression on him. "Because of Todd and because it was in North Beach, I was suddenly in this environment with guys who really took bartending seriously. Or really took cocktails seriously, specifically. And they knew all kinds of cocktails and they would talk about them." He fit in with them and became part of their community.

Their conversations extended beyond cocktails to spirit production. They all had a strong desire to learn more, which prompted them to take action. At a time when information about products wasn't readily available, they wanted more from brands. How were the spirits made? What were they made with? What was the impetus for their creation? "The fact that we were meeting and having these conversations made us want to start a bartenders' club," says Nepove.

The group was feeling frustrated about how information was passed from distillers to bartenders. "If a distiller came to San Francisco, like [Italian grappa producer] Jacopo Poli, he would hit up his biggest accounts," says Dionysos. "He would contact his distributor, and they would talk to their sales force and figure out what accounts in San Francisco sold the most grappa. He would do seminars for those staffs, and they would leave town. I remember trying desperately to get myself invited to a Jacopo Poli seminar

at Jardinière. I managed to get an invite, but I was sitting in with their staff as kind of an intruder. I said, 'This is crazy. This is crazy." He knew there were enough interested bartenders to warrant more open educational practices. He wanted to organize a group so that distillers would contact them when they were in town.

The group put things in action after attending the annual Nightclub & Bar Trade Show in Las Vegas. A few San Franciscans would go each year, using it as an excuse to see Tony Abou-Ganim at the Bellagio. "Tony was the first ambassador for bartenders on the West Coast," says Nepove. They would visit him at the Bellagio bar and chat with him. From these visits, they learned that he had formed a Las Vegas chapter of the USBG. Abou-Ganim and Francesco Lafranconi, executive director of mixology and spirits education for Southern Wine and Spirits, headed their effort. "Francesco Lafranconi had started his Academy of Spirit and Fine Service, and every person who graduated automatically became a member of the Bartenders' Guild. Their chapter was just growing like crazy. And every person that was hired at the Bellagio was put through the academy and were becoming members of the guild. Vegas became the new national headquarters," Dionysos says. Bezuidenhout adds, "A lot of us wanting to do a chapter in San Francisco was through that Vegas influence."

Abou-Ganim and Lafranconi helped the group along in the early days. "It was a long, slow process," recalls Dionysos. "Initially, we had to be attached to Los Angeles because you could only have one chapter per state. We were basically sending all of our dues to Southern California, and they were playing a lot more golf. It was really frustrating, but we got this connection going between us and Vegas." The Southern California chapter was much different than what the group envisioned for San Francisco, as they were originally required to have golf tournaments and luncheons. "We're like, 'That's got nothing to do with what we want it to be about. We can't play golf,'" says Bezuidenhout. "We were butting heads with them, but Las Vegas really helped us because they wanted the USBG to grow."

As they were formalizing their chapter, they started to meet regularly. "There wasn't an official first meeting. I think a lot of it started at Enrico's because they were open for lunch and we could just go there and sit outside and talk. I think one of the first proper meetings was at E&O. A buddy of ours, Chris Cashin, was a GM there," remembers Bezuidenhout. They had meetings at E&O, the Irish Bank, Enrico's and Tommy's. "It took us a really long time to figure out what we wanted to do as an actual chapter," he furthers.

After they settled on their objectives, they began asking brands to come speak to them. Brands did come and, in turn, took them to lunch. But just because these companies were paying the tab didn't mean the newly minted San Francisco USBG took it easy on them. Dionysos led the charge and asked probing questions. "We learned to ask the right questions because Marco asked the right questions," says Nepove. "He asked tough questions about sugar content and what proof they were distilling it to do or where the water was coming from."

Another function of the USBG was to act as a platform for cocktail competitions, which were picking up steam. Cocktail competitions, where bartenders would present a new drink that featured some type of ingredient—spirit, product or brand—to a panel of judges, was becoming an important place to both network and push the boundaries of their creativity. "There weren't that many cocktail competitions back then in the '90s," explains Nepove. "But as vodka became more important and as brands started spending more money on promotion, contests did start to come. The real change in cocktail competitions happened after 2002 when the USBG started getting more involved. The rules really started to change for cocktail competitions. There were actually important rules in how you make a drink and what it means to be creative."

The group caught the attention of Simon Ford, the international brand ambassador for Plymouth Gin. Ford, a former bartender, understood their desire for information. He took them to the Plymouth distillery in England, one of the first tours of its kind, in response to their unrelenting desire to know what was actually in the bottle. "They took us to see the distillery and hear their story and see the water source. After that, every great bartender wanted to sell Plymouth Gin because of Simon Ford and the amount of information that he helped us gather to teach us about cocktails," says Nepove. Through these trips and his work with Plymouth, Ford began to connect the larger industry. He took bartenders from different cities on the trips, which cultivated strong ties between places where cocktail culture was beginning to boom. "Simon had this worldly idea," says Bezuidenhout. "Plymouth really connected San Francisco, New York and London."

Word started getting out to others in San Francisco about the USBG. It attracted Martin Cate, a tiki enthusiast who worked in transportation logistics. "I was basically a travel agent for cargo lines," Cate says. Though the entirety of Cate's professional life took place in an office, he was privately diving deeper into the world of tiki. He and his wife, Rebecca, set up a home tiki bar (their first, located in their apartment in the perpetually

overcast Richmond neighborhood of San Francisco, was called the Foggy Grotto). They threw parties for their friends, where Cate started to develop his bartending skills. After his last employer went bankrupt and he had the unenviable job of delivering the news to longtime employees, he chose bartending at Trader Vic's second location in San Francisco as a temporary way to bring in income.

Cate's first USBG meeting was transformative for him. "My first meeting was at Tommy's Mexican Restaurant," he explains. "It was sponsored by El Tesoro Tequila. I walked in, and I met David Nepove for the first time. I sat down, listened to him talk about El Tesoro tequila and Julio Bermejo pontificate a little bit, and it blew my mind. It blew my mind. All of the bartenders there were asking great questions. 'Tell me what kind of tahona they use and do they use an autoclave?' 'How do they process the agave?' I couldn't believe there were people who didn't just tend bar, but wanted to learn a lot, wanted to explore and experience every nuance of the spirits so they could share it with their guests. I left that place on cloud nine. I was skipping through the clouds. I called Rebecca and said, 'I know what I want to do for the rest of my life. This is it. I'm in hospitality. I can't believe how interesting and creative these people are.' I was a little tipsy from the tequila, but I thought, this is it. I'm done. Truth be told, that was one of the most liberating sensations. I'd always had professional uncertainty. I'd always wondered what I wanted to do for a living. Now, I don't have to worry anymore. I don't have to think about it. And that was just a sense of unbelievable freedom for me. I still feel the same."

Even with people like Cate joining, membership was sluggish at first. There were only about ten members in the first few years, who included Nepove, Dionysos, Bezuidenhout, Cate, Julio Bermejo, Greg Lindgren, Eric Johnson, Shane McKnight, Thomas Waugh, Dominic Venegas, Reza Esmaili, Duggan McDonnell, Tim Stookey, Jonny Raglin, Carlos Yturria, H. Joseph Erhmann, Todd Smith, Jackie Patterson and Ryan Fitzgerald. Nepove was running the guild with Dionysos and Bezuidenhout. In 2006, Jon Santer was elected president. "I was president for two years," says Santer. "I didn't do as much as David did, not even close, but we did manage to grow membership. We grew it from 32 to about 120 by the time I left the presidency. It was still education and community based. People were getting jobs and meeting other bartenders from all over the city through it."

These early USBG meetings broke bartenders out of their silos. Some knew one another from word of mouth or paying visits to one another's

bars, but many didn't have personal relationships. Jonny Raglin remembers attending his first USBG meeting with Jeff Hollinger, both partners of Comstock Saloon. "I think that Jeff and I were members sixteen and seventeen, which was very, very early on in the game," he says. "But what we found at our very first USBG meeting, which was at Tommy's Mexican Restaurant, was that we knew these bartenders from coming and sitting at their bars. Once we started to come together, we were hanging out together, sharing a few ideas, sharing a lot of drinks and building friendships amongst people that were really competing against each other."

Neyah White, a bartender at Nopa in San Francisco's Western Addition neighborhood, felt the same way. "By the end of 2006, I had thirty-five new best friends," White says. "And we felt that way around each other. We supported each other, we went drinking together—more importantly, we went to each other's places and gave honest feedback." Scott Baird remembers this too. "We all knew each other and checked each other out; we were always kicking each other's tires and making sure we didn't not know something," he says. Out of the USBG grew a standard for cocktails around the city. Drinks now had to be thoughtful, balanced, their ingredients proportionate and the juice fresh. It was no longer enough to fall back on the comfort of drinks that sold well, like Vodka Gimlets, Cosmpolitans or Dirty Martinis. Menus were expected to have a point of view and incorporate spirits like gin, whiskey, rum and even sherry.

People took notice of these changes. Customers started to expect a good drink at more bars. "That's when writers started coming in," says White. "Not necessarily drinks writers, but lifestyle writers who knew we were on to something. And the clientele of San Francisco absolutely loved it." To boot, bars became the profit centers of restaurants. "Chefs had figured out at some point that profits come from the bars," says Jon Santer, owner of Prizefighter. "They said, 'Let's charge a lot for drinks and hype them a little bit. Let's take some of the limelight off ourselves and give to the bar so we can make some more money because our food costs are too high but the bar costs are lower.' I think that was really more of a practical decision that was thrust upon us. We were kind of greedy for attention because we had felt we knew that the profits come from the bar but we never got mentioned." Thus, bartenders could provide themselves with a nice living in an expensive city.

The Cocktail Book Revolution

While articles about cocktails have been showing up in the *San Francisco Chronicle* since the 1860s, it wasn't until the late 1990s that drink writing took its current form. Though he didn't mention cocktails in his early days, Michael Bauer was the first incarnation of anything that resembled a modern cocktail writer. Bauer is the food editor of the *San Francisco Chronicle*, a position that he has held since 1986. In the days before the Internet was everywhere, Bauer was the all-mighty food critic whose word people took as law. He would visit a restaurant twice, unannounced, often using a pseudonym, before writing a review. Though the *Chronicle* never ran a photo of his face, restaurant managers who had been around the block knew who he was immediately. Staff members were often given instructions for his visits so they had the tools to act cool under fire. Owners would show up suddenly, almost as if a Bat Phone had summoned them. Bauer's visits were important. He would write his review and then award the restaurant some number of stars, which had a profound impact on business.

Because he was the most notable critic in town, he yielded a healthy amount of sway with his readers. He had the power to make restaurants the hottest place in town. It happened in 2008 at Range, a restaurant that Carlos Yturria opened as the bar manager in 2005. "When Range gets the review, the Mission goes off," Yturria says. "It changes the Mission. It's the biggest thing that happens to us. The power of the pen, oh my goodness." Jon Santer was bartending there on Sunday nights at the time. He remembers that before Bauer's review came out, Sundays were a relatively quiet night. After the review was published, however, there was a line of people waiting at the door for him to open up every week.

"Bauer was all-powerful," says Jon Santer. "Quite literally all-powerful. If you got three stars, you made it. If you got two and a half, you closed." And close restaurants he did. "If you got a negative review, you were in trouble," says Carlos Yturria, owner of the Treasury. "It shut restaurants. People that I knew, people like me who put all of their life savings into a place they believed in. Honestly, I get a little choked up about it. It crushes people. It's crazy."

Both scenarios happened at Enrico's in North Beach. Back when Paul Harrington worked there, an article by Gary Wolf mentioned Harrington's drinks, effectively starting the Mojito craze in San Francisco. People came in and ordered directly from the newspaper. (This caused Harrington to become disillusioned with his interactions with guests, and he went back to

the Townhouse in the East Bay shortly after.) When Bauer reviewed Enrico's in 2005, he gave them a single star. It shuttered for good the following year.

Many bartenders relished the attention that Bauer was finally paying to cocktails. For years, Bauer wouldn't mention bars at all, even if the restaurant was known for its cocktail program. "He'd mention price of wine and wine lists but nothing about bars for a very long time," says Santer. "Everybody felt kind of slighted by that. When we started to get a little bit of attention, we were all excited about it. It made me feel like I had a legitimate job."

As the popularity of cocktails grew, the *Chronicle* saw the need to employ a writer who regularly covered the beat. In 2001, they hired Gary Regan, a New York–based bartender-turned-writer. He wrote remotely from the East Coast about the Bay Area. It was a curious choice to outsource this to a writer who lived three thousand miles away, but it was likely due to the limited number of available professional drinks writers. "I don't think there were a lot of people who specialized in just cocktail writing," says drinks journalist Lou Bustamante.

Despite his lack of proximity, Regan managed to cover many of the new bars and drinks that were becoming popular in the Bay Area cocktail scene. He would discuss emerging trends and the people who were behind them. This further pushed bartenders into the spotlight, helping many launch their careers in a more public way. "Gary was probably the most important single figure in the early game for us," says Jonny Raglin. One such bartender was Neyah White, who was working at Nopa. Regan wrote about his White Manhattan, a riff on the classic version. "There is not one person who has ever done anything more for my career than Gary Regan," says Neyah White. "Neyah's drink became the talk of the town," says Raglin.

Regan's success as a drinks writer helped create relationships between writers and bartenders. In 2007, Camper English, a San Francisco–based freelance journalist, began to write for the *San Francisco Chronicle*. English had his finger on the pulse of the cocktail scene, which meant he knew a lot of bartenders and was treated well by them. He went on to start "Alcademics," a forum for industry news and product reviews. Brooke Arthur, who worked at Range, was aware of how important it was to maintain good relationships with writers. "You treated them like royalty when they came in. You always wanted them to do as many favors for you as you would do for them," she says.

Martin Cate also realized the importance of these relationships between the time when he later opened his first bar, Forbidden Island,

and his second bar, Smuggler's Cove. He says of this, "Between 2006 and 2009, I worked really, really hard and conscientiously to form good relationships with the media. I had really loved talking to reporters at all these magazines. Pretty soon people at the *San Francisco Chronicle*, the *Examiner* and the *Weekly* started to take notice of Forbidden Island. We started getting national press. I think we were mentioned in the *New York Times*. But I really cultivated those relationships. I was always very conscious of responding immediately to reporters and getting them the information they wanted right away. I tried to make myself really available. And it turned out to be a really smart move in terms of forming good bonds."

Jon Bonne, the *San Francisco Chronicle*'s longtime wine writer, occasionally dabbled in cocktails. He created the annual Bar Stars recognition in 2008. It put a spotlight on a handful of the city's bar talent each year, which provided a nice career boost for the bartenders who were recognized. White, Raglin, Julio Bermejo, Erik Adkins, Scott Beattie, Jacques Bezuidenhout, Todd Smith, Duggan McDonnell, Jeff Hollinger, H. Joseph Ehrmann, Doug Bierderbeck and Alberta Straub were in the first cohort. Both bartenders and writers benefited from their reciprocal relationships. Bartenders provided writers with content, while writers made drinks a legitimate topic in food writing.

As drinks became an increasingly big part of food writing, cocktail books became more popular. Publishers began to seek out well-known bartenders to write books on booze, as well as writers who had been covering the cocktail beat. William Grimes, writer for the *New York Times*, published *Straight Up or On the Rocks* in 2002; Dale DeGroff published his *The Art of the Cocktail* the same year; historian David Wondrich published *Imbibe!* in 2008 (after writing the cocktail column for *Esquire*); historian Ted Haigh published *Vintage Spirits and Forgotten Cocktails* in 2009; Gary Regan (now Gaz Regan) published *The Cocktailian Chronicles* in 2010; and Jim Meehan published *PDT*, a recipe book named after his bar, in 2011. The Bay Area's own Jeff Hollinger, co-owner of Comstock Saloon, published *The Art of the Bar* in 2006, while Scott Beattie published *Artisanal Cocktails* in 2008. Numerous trade publications came out, including *Imbibe* magazine and *Drink Me*. *Food & Wine* had a cocktail issue, as did many other lifestyle magazines. National food blogs like Eater and Serious Eats started their own cocktail columns. Cocktail writing was now a staple of culinary literature.

Just as Bay Area bartenders were transferring their expertise behind the bar to the written word, cocktail writing provided opportunities to other career paths in the industry. Erik Ellestad created the Savoy Stomp blog, in which he chronicled his way through Harry Craddock's 1930 *The Savoy*

Cocktail Book and occasionally interviewed bartenders. Through this project, he discovered his love for bartending and got a job with Erik Adkins when he opened Heaven's Dog. Rick Dobbs wrote the blog Martini Time when he was working at an office. Later, he opened his own bar, the Last Word, in Livermore, California. Another example of this is Umami Mart, a blog that turned into a brick and mortar store in Oakland.

Kayoko Akabori and Yoko Kumano, two childhood friends from Cupertino, California, started Umami Mart. Their early career aspirations took them to different parts of the world, Akabori to New York and Kumano to Tokyo. They reconnected in 2006 and bonded over their love for food and drink. They decided to stay in touch and share their forays into restaurant culture, kitchen recipes and packaging design. Their correspondence manifested as a blog so others could read about their experiences. "I wanted to start a blog because it was an easy platform to get my opinions out to the world," Akabori says. Inspired by a Japanese supermarket in New York called Jas Mart, Akabori named the blog "Umami Mart," which they launched in 2007. They asked several friends who lived in different parts of the world to write columns for them. One of the columns was called "Happy Hour," in which cocktails were the star of the show. "We quickly discovered that these posts were the most widely read," Kumano says.

Yoko Kumano and Kayoko Akabori, owners of Umami Mart, at their shop in Oakland. *Photo by Jon Santer.*

In 2010, both Akabori and Kumano found themselves back in the Bay Area. At a time when they were both reassessing their careers, they decided to expand the blog into an online store. They knew that most stores in the United States weren't selling any Japanese drinkware, such as bar tools. Japan had long been regarded for its advanced bartending techniques, so they decided to test the water with these products. They gradually started to import bar tools, sake ware and tea ware from Japan. "It was really limited when we started," says Akabori. "We had cases in tiny quantities. The online store didn't catch on immediately." "At first, nothing happened. It was like tumbleweeds," says Kumano. "And then we started getting more orders, but because we were ordering

Sake, used in cocktails in the Bay Area. *Photo by Nando Alvarez-Perez and Vaughan Glidden. Courtesy of Ramen Shop and Umami Mart.*

such small quantities from Japan, we would sell out quickly. Pretty soon, my apartment was full of stuff: peanuts, boxes and inventory."

What began as an effort to clear out Kumano's apartment turned into the brick and mortar version of Umami Mart, which now holds court in downtown Oakland. They won a small grant from Pop-Up Hood for six months of free rent on a storefront as an effort to rejuvenate the neighborhood. They worked hard to turn the space into their own. They created a bright, clean shop that stocks beautiful products. Their opening party was packed, and their customer base has only grown since.

Bar tools account for the majority of their sales, both in store and online. Many local bartenders are among their most loyal customers. Neyah White was one of their first supporters. Now bars around the Bay Area proudly display their tools and glassware on the bar. Akabori and Kumano have worked hard to cultivate meaningful relationships with bartenders. It is an example of the reciprocal relationships that make the Bay Area cocktail community so strong, with people from different corners of the industry supporting one another's endeavors. They also sell cocktail books and routinely host events. They have become a place that brings the bar community together, all while celebrating Japanese drink culture.

SAN FRANCISCO COCKTAIL WEEK

The desire for information and community manifested in ways other than professional groups and writing—it also came in the form of educational events. Cocktail conferences had started to spring up in New York and New Orleans, which featured seminars, book readings and parties. In May 2007, San Francisco hosted its first cocktail week. San Francisco Cocktail Week (SFCW) was the brainchild of Duggan McDonnell, Jeff Hollinger and H. Joseph Ehrmann. "Gary Regan and Dale DeGroff were working a World Cocktail day in New York," McDonnell says. "I said to Jeff, 'One day isn't enough! Let's do it for the week.' The goal was to educate the average citizen."

They created curricula to honor their education-driven mission. There were events that included an opening gala, cocktail demos, guest bartending nights, a cocktail dinner, seminars on cocktail history and fundraisers. "Events developed organically. We included a benefit for the Museum of the American Cocktail, which is how we heard of this funny little festival sponsored by Southern Comfort called Tales of the Cocktail," McDonnell says. (Tales of the Cocktail, based in New Orleans, would live on to become the biggest cocktail convention in the country.)

The events of the week drew large crowds, and SFCW would be the West Coast's biggest festival for a number of years. "SFCW grew virally year after year. We took on Ellipses Public Relations [to help promote it], which boosted the brand to an international level. It garnered more media for cocktails in San Francisco and thoroughly wove the conversation into the fabric of the community. Cocktail classes became de rigeur. We met a basic, unfulfilled need for knowledge. And inebriation," says McDonnell.

Through his work on SFCW, McDonnell formed a strong relationship with the Center for Urban Education about Sustainable Agriculture. He, Hollinger and Ehrmann contacted CUESA and met Christine Farren, who was overseeing some of their programming. "They approached me about hosting a farmers' market–based event at the Ferry Buildings as a part of the week," Farren says. "I was really hesitant at first because I wasn't sure what role a big boozy event had to play in sustainable agriculture, but I said yes." The event, which was a success, kicked off the 2008 SFCW. After this, Farren started noticing bartenders coming to the farmers' market to shop for the bar. She saw Dominic Venegas, Scott Baird, Greg Lindgren, John Gasparini and Martin Cate come by regularly. They did a second event in 2009, which led to a semi-annual event called Cocktails of the

Farmers' Market. Members of the United States Bartenders' Guild were invited to create a cocktail from seasonal produce that could be found at the Ferry Building Farmer's Market. They would serve their drinks at the event. CUESA opened up its lab space—typically used for chefs—to bartenders to workshop their drinks. As a result, bartenders got to hone their skills, take a culinary approach to the craft, learn about incorporating seasonality into their bar programs and educate the general public at the events. It is yet another example of the reciprocal relationships that unite different facets of the community.

Executing an event on this scale was a lot of work, and Duggan, Hollinger and Ehrmann got burned out. They eventually stepped down from planning and handed the event off. "It was incredibly hard work," explains McDonnell. "It look a toll on our businesses and our families. We exhausted thousands of hours and dollars on it. After five years, each of us could no longer give it the dedication it deserved, which is why the festival folded a year after we handed over the reins."

A BAR ON EVERY CORNER

THE COCKTAIL BOOM

The cocktail renaissance had picked up steam by the mid-aughts. More restaurants were focusing their energy on their bars as the demand for quality drinks increased. And then in 2006, everything changed when Bourbon & Branch opened, a little bar on the corner of an edgy intersection in San Francisco's Tenderloin neighborhood. Bourbon & Branch's menu featured classic cocktails and had no kitchen, challenging the idea that bars needed to be attached to restaurants to be successful.

Leading up to Bourbon & Branch's opening, more places were earning a reputation for their quality beverage programs. The popularity of these restaurant bars engendered Bourbon & Branch's ascendancy. Foreign Cinema and Range opened in the Mission, Frisson and 15 Romolo opened in North Beach and César was going strong across the bay in Berkeley. Several of the bartenders who gave Bourbon & Branch its star power worked at these places, enabling the bar to open with immediate success.

THINGS CHANGE IN THE MISSION

Foreign Cinema opened in 1999 in the Mission district of San Francisco. At the time, there weren't any fine dining restaurants on Mission Street, making it a destination for those in the know. "We had two immaculately dressed doormen on Mission Street because it was a little daunting for people to come from

other parts of the city. There needed to be someone of stature looking elegant standing on the curb welcoming people and opening the door," says Bryan Ranere, one of the original bartenders. Harveen Khera was their opening bar manager, who brought on Ranere and Phil Mauro to bartend. "Right away it was talked about like, 'Everything is going to be made from scratch, everything is going to be made with fresh juice and sugar.' Harveen was sort of taking some of the best things from bars all around the city," says Ranere. One of the draws of Foreign Cinema was its backyard dining area, where they used a 35mm projector to play films onto a screen on the wall. "They thought it was going to be a real culture scene where people were coming to see movies and would have some food and some wine," remembers Ranere. The food and cocktails ended up being the main attraction while the movies were a supporting backdrop, and they were busy as soon as they opened. "It was this huge dining space, and we had a very small kitchen to serve three-hundred-plus covers a night. It was pretty pretty taxing," Ranere says. "But there was nothing even close to what we did with food, cocktails and sensory experience at the time. We were the vanguard."

Ranere had a love of film, having studied it in college and making one of his own, which attracted him to the project. He and Mauro worked in the trenches together on busy Thursday, Friday and Saturday nights. "In those early days, it was us behind that big bar just kind of rocking it," Ranere recalls. "And Phil is a machine. He's a machine of efficiency, and I learned a lot about efficiency from him for sure." Mauro had barbacked for Tony Abou-Ganim at the Starlight Room when he was starting out, from whom he learned a lot about economy of motion and hospitality. He had also bartended at Scala's Bistro and Café Espresso before joining the team at Foreign Cinema in 1999.

In 2000, with the immediate success of Foreign Cinema, the owners bought Bruno's, a bar across the street. Bruno's had been closed for a couple years, but the team wanted to give it a second life. Khera, Mauro and most of the opening bar staff—except for Ranere—relocated to Bruno's when it opened. "I was asked to stay behind and hold down the fort at Foreign Cinema," says Ranere. He kept the bar running and took more ownership over the program. He did end up at Bruno's later as the bar manager, albeit briefly. Around this time, there were plans to open a bar in the front of Foreign Cinema, called Laszlo ("The original concept was bar science," explains Mauro), which Ranere returned to run. When Khera left shortly after to open her own bar, Ranere took over as bar manager and ran the program for both Foreign Cinema and Laszlo.

The following year, in 2001, Chef Gayle Pirie and John Clark, who had worked together at Zuni Café (and Pirie at Chez Panisse as Alice Waters' assistant), took over the kitchen. Ranere, now in charge of the beverage program, worked closely with Pirie on menu development. As a filmmaker, his goal was to use aesthetic to inform the cocktails and connect to movies (he was also programing the movies for Foreign Cinema and Laszlo). "Gayle and I would talk a lot about what was on the horizon in terms of fresh produce and flavors. One of our earliest collaborations was this jam she made with berries. She wanted me to taste it and see if it worked in a cocktail. The fruit and the color was really exciting, and I wanted to contrast it with some citrus. It needed a clean vessel, so I used vodka. There was something very sexy about it. I wanted the cocktail list to have an intrinsic relationship to films, and there was a movie that I loved called *Sexy Beast*. The drink was good, but the name was even better. We must have sold a hundred thousand Sexy Beasts," Ranere says.

Foreign Cinema and Laszlo's popularity attracted industry up-and-comers. "Everybody wanted to work there," says Ranere. "It was a really desirable place to be." Spots on the bar team were hard to come by because there was very little staff turnover. It drew Ryan Fitzgerald, owner of ABV, who started there as a barback. Jon Santer, owner of Prizefighter, worked at Bruno's as the bar manager. Ranere hired many of the bartenders and barbacks and mentored a lot of his young staff, many of whom went on to have successful careers in the industry. He earned a reputation for his grace under fire, allowing his staff to learn from calmness. "He was always mellow," says Mauro. "I was more panicky and he was like, 'It's okay. Everything is going to be all right.'" The bar staff and the atmosphere drew other bartenders, and the bar soon became an industry favorite. Between the elevated food, unique sensory experience, cocktail program and spirit selection that Ranere spent over a decade building and its reputation for launching careers, Foreign Cinema created a space that even today is unrivaled. "What we built there became an institution," says Ranere.

A few years later, in 2005, Range opened a few blocks away from Foreign Cinema. Husband-and-wife duo Phil and Cameron West had a vision for a restaurant that served refined California cuisine with a beverage program to match. They enlisted Carlos Yturria, a rising young bartender who had drive and curiosity. It didn't take convincing for him to sign on with the project, having worked with the Wests before, but the location of the new place gave him pause. Yturria recalls his reaction: "Phil West is like, 'We are going to take over this space.' I'm like, Where?' 'In the Mission, on Nineteenth and Valencia.' I'm like, 'You are crazy! You are out of your

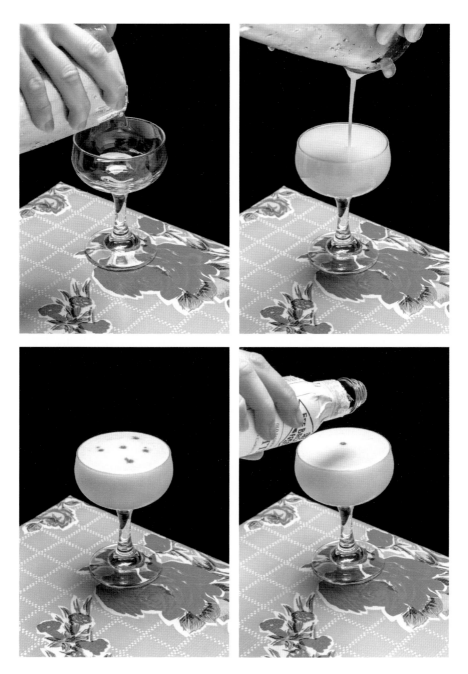

Clockwise from top left: Coupe glass, tins and strainer; pouring a Pisco Sour; adding bitters to a Pisco Sour; bitters added to a Pisco Sour. *Photos by Nando Alvarez-Perez and Vaughan Glidden.*

mind!' It was next door to Needle Park, a place that earned its nickname for the rampant drug use that took place there."* The Wests followed the ethos, "If you build it, they will come." And come they did. Although Yturria had initially been skeptical about Range's location, the neighborhood was ready for it. "People were getting excited about the space," Yturria says. "When we opened, people were excited about cocktails."

The Wests were restaurant people, and they knew Yturria would put together a program that could match the level of food they were serving. Yturria took a culinary approach to the cocktail program. "He was muddling everything, all of the ingredients," says Brooke Arthur, who worked with him at Range. "People definitely came for the drinks and the bartenders." Yturria worked closely with the chef, who cared deeply about seasonality. "It was really about what's in season. He would pull ingredients two weeks before they were out of season and be on to the next thing. That was the real push for me to be creative," he says. The bar was treated with the same respect as the kitchen, something that was typically a struggle (like when Marco Dionysos had to fight for space in the walk-in refrigerator to store necessary ingredients at Absinthe). "We had this room that was especially for fruit," Yturria says. "It was kept at a certain temperature for the fruit. I don't think anybody has that. Still, no bar I've ever worked at."

Yturria put together a strong bar team he knew could execute the drinks and educate one another. He recruited Dominic Venegas, who was working as a spirits buyer for the liquor store John Walker's. The entire staff benefited from Venegas' spirit knowledge, as well as his experience behind the bar. He hired Jon Santer, who worked on Sunday nights. "He was amazing. He shows me how to stir," says Yturria. Arthur, who was coming up as a bartender after being a server for years, worked diligently under Yturria. "I didn't do any real cocktail development for the first year," she says. Venegas helped coach her, and she encouraged her to watch other people work. Eventually, when Yturria later left, she started managing the bar. Arthur's work there earned her some positive attention from the media and recognition from her peers. She went on to become a 2008 *San Francisco Chronicle* "Bar Star." (Thad Vogler was also in this group. "It was a really big deal then," she says. "It was my face next to Thad Vogler's in the article. That was really intense for me.") Range's bar staff attracted an ardent group of fans. "It had this crazy group

* Once open, the FBI tried to set up a surveillance unit at the restaurant. Yturria remembers Phil West being adamantly opposed to this out of fear there would be retaliation. "They will burn my restaurant down!" West said. The park was later cleaned up and has outlived its nickname.

of regulars. They were the greatest. And all of the old-school bartenders from around San Francisco came in," Arthur says. Range continued to be a neighborhood favorite until it closed in 2017, when the Wests decided to revamp the space and the concept. Yturria came back on board to help them with the remodel.

BACK IN NORTH BEACH

One of the reasons that North Beach was a hub for cocktails was because of 15 Romolo. "It's a bartender's bar," says Scott Baird, owner of Trick Dog. "It was an industry bar by design." Greg Lindgren and Jon Gasparini opened it in 1998. It's in a building that was once a brothel and later a boardinghouse called the Basque Hotel. It's a dark bar located in an alley off the main drag of Columbus Avenue. They serve California-style cuisine, which uses fresh seasonal ingredients. It's become a stalwart in San Francisco's cocktail scene where many of the city's best bartenders have worked, including Baird, who eventually went on to become an owner and create its food program. It's an important spot in the cocktail community where people have shared drinks, swapped stories and created many memories.

Around the corner from 15 Romolo, on Jackson Street, was Frisson. Duggan McDonnell helped open it in 2004, a gig that helped launch his career. It had a chic, modern design that used pink and orange colors to make the dining room pop. The food and wine was refined, and McDonnell gave the bar some splashy energy. He channeled his interest in food and aromas into the cocktail menu. At the time, flavored vodka Martinis were the latest drink trend finding its way onto menus all over the country. McDonnell, whose goal is to make every cocktail balanced, added his unique spin on the craze and created the XXX Martini. The drink is a concoction of vodka, a dash of squid ink and an olive garnish. The unconventional ingredients coupled with its color (black) and name earned him national media attention and put both him and Frisson in the spotlight. "My motive [for creating that drink] was why the fuck not? The recipe makes perfect sense from a flavor perspective. I never imagined it would garner national acclaim and haunt me for a dozen years!" he says. Brooke Arthur, former bar manager of Range, joined the staff and worked closely with McDonnell. "It was a really crazy concept," she says. "It was the coolest thing when it opened. Duggan and I worked really closely there." Though it shuttered in 2008, McDonnell and his XXX Martini will continue to live on in North Beach infamy.

ACROSS THE BAY

In 1998, César opened next to Chez Panisse in Berkeley. It was a bit of a waiting room for Chez Panisse (with similar ownership); many people came in to wait for their table next door. César had an extensive beverage program and became a cocktail destination, especially after Paul Harrington left the Townhouse Bar & Grill. "They always had a great cocktail program. It was lots of house originals. Their Martini had Pastis in it, which if you can imagine in 1998, putting Pastis in vodka, convincing someone to drink anise, that's crazy. That's a bold move in 1998. It's a bold move now, let's be honest," says Dylan O'Brien. They also became known for their team, which included O'Brien, Scott Baird and Jessica Maria—all of whom went on to own their own bars. "That's where I learned to bartend," Baird says. "I learned how to nerd out, how to be cool with guests and how to think about mechanics." He earned a reputation for his bespoke drinks, as well as his personality, after one of his regulars started asking him to make her a drink based on an adjective she would give him. "That's when I started breaking from the script," he says. Maria, who joined the staff after Baird left, remembers how much regulars loved him. "I would only hear stories about Scott Baird, Scott Baird, Scott Baird. It was Scott this, Scott that," she says. He went on to open Trick Dog, a bar in the Mission known for its innovative drinks that combine flavors more common in food than drinks, like miso, peanut, sage, sesame and whey. He developed this culinary approach to drinks while at César.

Baird, O'Brien and Maria all cite Dennis Lapuyade, a Chez Panisse alum and a wine professional, as a mentor. Lapuyade curated a phenomenal selection of spirits. "They had a massive spirits selection," says O'Brien. "It is not unusual now but was very unusual then. It was very well selected—lots of rarities, lots of things that people still don't drink now, like every eau de vie that St. George Spirits makes. They had very obscure scotch whiskies. We had fifty scotches, most of which no one had ever heard of." Lapuyade helped them cultivate their palates and allowed them to develop their spirit knowledge there. "When I started there, it really boosted my knowledge for the back bar spirits," says Maria. Similarly, O'Brien says, "That was such a tremendous education, having access to that back bar. They were great from early on, saying, 'Taste something every day. Every shift, when you come in, try something that you've never had. And read the label. Commit it to memory. Look it up when you get home and learn whatever you can about it so that you have a story, you have a flavor memory, you have experience,

and as you start going to more and more things, you'll be able to relate back to things that you already know and you just sort of build this web of knowledge.'" The back bar was so good that it drew people from across the bay. "Marco Dionysos, Jacques Bezuidenhout and David Nepove used to come in because the spirit selection was better than anywhere in San Francisco," corroborates Baird. Indeed, César kept cocktail culture alive in the East Bay.

THE BAR THAT CHANGED IT ALL

Bourbon & Branch is a dark, wooden den of a bar located in San Francisco's Tenderloin neighborhood. The bar, marked only by the "Anti-Saloon League" sign hanging from its façade, is located on the corner of Jones and O'Farrell Streets in an area notorious for its high drug and crime rate.* The bar that originally inhabited the space operated illegally during Prohibition, using underground catacombs to move and store liquor. The bar's history created a touch of mystique and matched its speakeasy-style concept. The bar was the third for owners Brian Sheehy, Dahi Donnelly and Doug Dalton, none of whom were known for their cocktails. They had opened Anu, which later closed, and Swig, a club on Geary Street, in 2003. They wanted to venture into something more civilized than clubs, so they decided to open a cocktail bar. They met Todd Smith, an industry veteran who had been a part of the Enrico's crew in North Beach, when he was working nearby as the bar manager at Cortez. Smith, who had started in the industry as a host, had worked almost all positions on the floor of restaurants before moving to the bar. The team felt that Smith was the perfect person to help execute their new project, and it was Smith who came up with the concept. "He created Bourbon & Branch," says Ryan Fitzgerald, who now co-owns ABV with Smith. "He did everything. It was Todd's creation and wouldn't have happened if it wasn't for him."

* The neighborhood, just 0.35 square miles, used to be called St. Ann's Valley. Historian Herbert Asbury started referring to it as the Tenderloin as early as the 1890s, and it officially appeared that way on maps by the 1930s. There are several theories as to how it earned its moniker, but all are related to crime. One theory goes that a police captain who worked the beat would take bribes to ignore crime and would talk about being able to afford filet mignon. Another posits that it was the soft underbelly of crime, akin to the part of the cow that is cut to make filet mignon. Others say it was because of the prostitutes, or the hazard pay that police officers got for working the area, or the shape that the neighborhood boundary resembles on a map.

Todd Smith. *Photo by Jon Santer.*

In preparation for the design and build-out of the venue, Smith took Sheehy, Donnelly and Dahi to New York for a bar tour. Their stops included Sasha Petraske's little speakeasy, Milk & Honey, which opened in 1999. Milk & Honey is often cited as ground zero for the cocktail renaissance,* the first of its kind in New York since Prohibition. Petraske chose an unassuming, kitchenless space in a residential building on the Lower East Side of Manhattan. He made classic cocktails, cared about history and aesthetic and was meticulous about his recipes, ice and technique. This bar left an impression on countless bartenders, especially those lucky enough to have been there when Petraske was behind the bar.† It left an impression on Smith, who took many cues from the space.

They also visited Pegu Club, a bar owned by Audrey Saunders, the protégé of famed New York bartender Dale DeGroff.‡ Saunders opened Pegu Club in Greenwich Village in 2005. It was a gin-focused bar, something that seems

* Absinthe opened in 1998, beating Milk & Honey by a year.
† Petraske died unexpectedly in 2015. Milk & Honey is now closed, but two of Petraske's protégés opened a new place in its stead, Attaboy.
‡ Erik Adkins once visited New York with his wife, and they, too, went to the Pegu Club. Saunders was behind the bar and spent an hour making them different gin cocktails. After trying all the drinks, Adkins' wife looked at him and asked, "Why don't your drinks taste like this?" This experience changed his life, as it inspired him to dig deeper and make better drinks. He now counts Saunders as one of his biggest influences.

progressive in a time when vodka easily outsold every other spirit category. Not only does gin show up in many classic cocktail recipes, but Smith had a penchant for it. "I didn't know him yet, but I was eavesdropping on Todd Smith talking about gin," says Neyah White. "I almost wanted to stop and take notes."

When Smith, Sheehy, Donnelly and Dalton returned, they put their plan for Bourbon & Branch into motion, starting with the build-out. "Todd was building the bar with this other guy, Darin, who is this kind of master carpenter who could build anything," says Jon Santer, whom Smith brought in to work on the project. "They built that bar themselves. Sometimes they had help and Brian [Sheehy] and Dahi [Donnelly] would come down. I remember Brian tiling the bathroom. I remember Dahi being dirty and working on stuff a lot."

When Smith brought Santer on to help open the bar, he was working at Tres Agaves. "Todd told me what he wanted to do, which was like this totally radical idea," Santer remembers. "When he approached me, he said, 'This is really going to be about making great drinks. We are going to have great ice. We're going to treat drinks like food.' I didn't think San Francisco had the bandwidth to do it." The concept included a reservation system and an unmarked door, creating an air of exclusivity.

Santer wasn't the only one who was skeptical about the project. "I thought Jon was insane to be going there," says Ryan Fitzgerald, who was working with Santer at Tres Agaves at the time. "I was like, 'You're leaving this cash cow? We're making money. It's easy. We're making Margaritas, and you're going to work at a place where you need reservations?' I thought he was out of his mind."

Smith decided to call it Bourbon & Branch, a term he had picked up from Paul Harrington. The two had briefly been roommates in Oakland after having met at Enrico's. "At the Townhouse, there were a couple old guys who would come in, not a lot and not very regularly, but would order a Bourbon & Branch,"* Harrington says. "I always thought that was the coolest way to order. If someone ordered the drink that way, I bought it for them. It became my thing. Todd loved that story. He just ate it up. So when he opened a bar, he named it Bourbon & Branch."

The original idea was for the bar to serve great wine, great beer and great cocktails. They thought that it could be a place where the three

* If you order a bourbon and branch at a bar, it means you are asking for a pour of neat whiskey with a side of water. Adding a few drops of water into whiskey can help open it up and bring out more of its flavors.

categories lived in harmony, although there were over sixty cocktails on the opening menu. It turned out that all anyone wanted was cocktails. "The idea wasn't like 'Let's make a cocktail bar.' The idea was like 'Let's make the best place you can go and have a civilized drink.' Whatever it is, it'll be great. And it ended up being a cocktail monster, but that wasn't the real plan," Santer recalls.

They weren't ready for what happened next. They were packed every night, and the entire bar would fill up as soon as the doors opened. "We hadn't memorized all the drinks because we hadn't made them—we didn't have time," Santer recalls. "We were going to do a really soft opening so we could train, but it leaked to the press. The first night, we were booked solid. And we booked solid every night thereafter. We kept the recipes on Todd's computer, which was a white MacBook at the very end of the bar. The drink orders would come in, and I would have to crouch down and look up the drink on his computer, and then I'd shuffle back to my side of the bar and make the drinks. I remember doing that for the first two weeks because there was no actual time to go home and study." People were finally paying attention, and they were coming in droves. Without a kitchen, there was no food to help stem the flow of drink orders. The cocktail servers were green and the reservation didn't stagger parties by time, so they were immediately flooded with thirsty guests when they opened at 6:00 p.m. "At six o'clock, ninety-five people walk in. At 6:03, everybody gets dropped menus. At 6:10, ninety-five orders come in for drinks at the same time. If your order is number ninety-one through ninety-five, you're fucked," Santer says.

Operating without a kitchen space also meant they had to squeeze fresh juice and make their own syrups before shifts. They began to call it the restaurant because they felt more like chefs than bartenders. "A lot of the ingredients were bespoke, so Todd was busy making all those during the day," Santer says. "I would do all the other prep. There was no kitchen, so it was like hotplates in the basement."

Consequently, it became one of the most difficult jobs they had ever had. Dominic Venegas, who was recruited by Santer shortly after opening, remembers how tough it was. "It was fantastic that the bar took off, but it was hard work. It was a pain in my ass," he says. Santer says, "There was no help. There was nobody else who worked there. It was me, Todd and Dominic. Todd was there every day for six months. He lived like a block away or half a block away, so he didn't leave that one-block area for nine months. It was insanity. It was the hardest job ever." The amateur build-out of the bar didn't make things better. Santer worked the service well and

Homemade tincture. *Photo by Nando Alvarez-Perez and Vaughan Glidden.*

made drinks for guests at tables, while Smith worked the main bar. "When you opened the door, Todd was the first person you'd see, and I was in the service well," Santer says. The service well was positioned next to the dishwasher, which became a constant reminder of the little box in which Santer was standing. He says, "If the dishwasher door was open, there was no space to actually walk behind it to the other side of the bar. If I leaned too far to the left, my knee would hit the on button on the dishwasher and turn the dishwasher on, whether it was open or closed, spraying me with water."

Smith and Santer quickly realized that they needed more help, or at least a day off. When the two were working on the build-out of the bar, they frequented Nopa, a restaurant that specializes in organic wood-fired cuisine in Western Addition. Neyah White was bartending there and would often serve the tired duo. After White showed up at Bourbon & Branch's opening night, Smith approached him. "The next day, Todd shows up at the bar and goes, 'We need you to work with us. We need you here,'" White says. Venegas kept a couple of shifts, too. They leaned on each other to make sure they were getting it right. "Dominic and I typically worked together, and I don't think one of us put out a drink that the other didn't taste for the first three months," says White. "There was so much learning from each other. Egos aside, we stood in that tiny little space and taught each other a lot about how this style of drink works in that atmosphere."

It seemed that San Francisco's appetite for cocktails was insatiable. "We had this doorbell that was hooked up to an actual old-fashioned phone," says Santer. "It rang loudly. Every time somebody hit the doorbell, it would ring five times. It was supposed to be this really calm, quiet cocktailing environment, but the fucking phone would just ring all night because there was no host to answer it. So they just ripped it out of the wall at some point. It was supposed to be this really civilized experience that was completely uncivil, basically." The bar attracted bloggers, a growing group of people

who were taking to the Internet to write on topics including cocktails. The bartenders had a contentious relationship with bloggers at first. "I don't know if they knew it was a contentious relationship," says Santer. "They would sit in front of you when you were crazy busy, and they'd want to talk to you about the history and variations on the Last Word and what your opinion was. You are forced to have these conversations, and you can't leave. It was very challenging. We were like, 'Whatever, you're a tourist. You'll be into something else in a year.'" As their popularity mounted, so did the comparisons to Milk & Honey in New York. The more press they got, the more these accusations flew. Even some of the staff thought so. "They modeled that bar after Milk & Honey," says White. "It was all but a rip-off. But I had been to Milk & Honey, and I was glad that it was happening here," White says.

Eventually, the bar earned a reputation for service without a smile, perhaps because they were all overworked and the space was so physically demanding. "Bourbon & Branch was notorious for not having good hospitality," corroborates Ryan Fitzgerald. "We were assholes," says Venegas. White says, "The friendly conversation piece was really difficult to keep going. Our brains were on fire. It was stressful, to be honest." The list of rules on the door didn't help. These rules included: please speak-easy; no cellphone use; no standing at the bar; don't even think about asking for a Cosmo; smokers, use the backdoor; no photography; please be patient, our drinks are labor intensive; and please exit Bourbon & Branch quietly. The bar was supposed to be civil, emblematic in the staff's collared shirts, vests and ties, but became a place where bartenders routinely told their guests to *shhh*. "No one could *shhh* a room like Neyah and I," says Venegas.

Later, new staff joined the fold. Ryan Fitzgerald picked up a shift and worked one night a week. When Santer eventually left to do brand work for Martin Miller's Gin, Thad Vogler was hired to do a few shifts, adding to the bar's star power. "I thought I'd go work for Bourbon & Branch and there might be something to learn there," Vogler says. At this point, Vogler had built quite a résumé and had consulted on multiple bar programs around town. Smith and Fitzgerald were surprised that he wanted to work there. "I think Todd's first question to Thad was, 'Why in the world do you want to work here?'" says Fitzgerald. "Thad was like, 'I just want to see what you guys are doing. You get more press and more credit for really changing the way cocktails are being drank in this town. I want to know what it is about what you guys are doing." Their reputation grew stronger with Vogler on board.

Ryan Fitzgerald. *Photo by Jon Santer.*

As guests continued to order cocktails like crazy, the bar team realized they could do more to educate their patrons about spirits. This effort resulted in the Beverage Academy, which were small classes that focused on single spirit categories. "That was great fun and an intense time. That was just a lot of pressure, but we really thought this was a cool thing," says Fitzgerald. One staff member would focus on one spirit, usually in their realm of expertise. "Todd did the gin class, Dom did the scotch class, Jon did the bourbon class and I did the tequila class," says Fitzgerald. "It all made sense. It was kind of crazy that the four of us kind of all slotted perfectly into these different spirits. Justin Lew designed and created the books with pictures and descriptions and a glossary—it wouldn't have happened without him." These classes were a hit. In fact, Smith and Fitzgerald often get asked when they are going to resume these classes at ABV, the bar they co-own together.

Bourbon & Branch's success formally marked the modern revival of cocktail culture in the Bay Area. It proved there was a market for cocktail bars, and many new bars opened in the wake of its prosperity. It proved that cocktail bars could succeed without being secondary to food at restaurants. In 2007, it won "Best New Cocktail Bar" at Tales of the Cocktail's new Spirited Awards. Though the original team eventually moved on to other projects, the success of the Branch engendered the creation of Future Bars.

The Future Bars company used the speakeasy-style model for multiple new venues. They are mostly in the Financial District and all without food. They opened a slew of new bars after Bourbon & Branch. In 2009, Rickhouse opened. In 2012, both Tradition and Local Edition opened, the former just half a block away from Bourbon & Branch. Devil's Acre opened in 2014, Tupper & Reed in Berkeley opened in 2015 and Pagan Idol opened in 2016. The Future Bars group became a launchpad for many young bartenders. It was a place to learn speed, efficiency and more about spirits while making a lot of money. It became a specific type of bartending, almost like elevated club bartending. The dark, wooden bars remain popular, where customers are constant and hours are long.

The Year That Changed It All

Prior to 2006, there were fewer than fifteen places where you could get a quality drink. There was Tommy's, the tequila stalwart; Zuni Café; Jardinière; Farallon; Absinthe; the Slanted Door; Foreign Cinema; Range; Tres Agaves; and 15 Romolo. In 2006, six more cocktail bars opened in the Bay Area. Between 2007 and 2016, over sixty new places opened. In addition to Bourbon & Branch, 2006 also saw the opening of Nopa, the Alembic, Rye, Cantina and Forbidden Island, ushering in the cocktail revival. This explosion of cocktail bars indicated that people were beginning to appreciate quality drinks. They were in different neighborhoods (Forbidden Island was across the bay in Alameda), allowing people the ability to get a good drink in different corners of the city.

Nopa is in Western Addition on Divisadero, a long street that stretches through both residential and commercial areas. It's home to Alamo Square park and the Painted Ladies, the row of Victorian houses famously featured on the show *Full House*. Nopa occupies the southeastern corner of Divisadero and Hayes Streets, noticeable by its large glass windows that engulf most of its façade. Neyah White, who was on the opening team, says, "The goal was to be the soul of that street." Jonny Raglin, partner in Comstock Saloon, consulted on the project and designed the bar, though he left before it opened. A number of seasoned bartenders were hired to run the program. In fact, there was no bar manager for the first six months because the bar staff was so strong. They kept Raglin's opening menu, and the cocktail program immediately became one of the biggest draws. "I don't think they

Left: Stirring a Manhattan. *Photo by Nando Alvarez-Perez and Vaughan Glidden. Courtesy of Ramen Shop and Umami Mart.*

Right: Pouring a Manhattan into a garnished glass. *Photo by Nando Alvarez-Perez and Vaughan Glidden. Courtesy of Ramen Shop.*

thought many people were going to drink cocktails," White says. "We were the only cocktail bar in the neighborhood until Alembic opened. When that happened, we got busier." Bauer came in and included one of White's drinks in his review. The second line of the article read that they served "pitch perfect Manhattans," only fueling the public's interest. White became the first bar manager. He was also working at Bourbon & Branch and had his finger on the pulse of drink trends. He worked closely with Nate Matheson, whom he calls "unshakeable." White stayed there until 2009, when he had to give up bartending because of an old injury that was causing him constant pain. Yanni Kehagiaras took over for him. The two had worked at Bourbon & Branch together, and White knew that Kehagiaras would carry his torch and keep the drinks on top.

The Alembic opened later that year in the famed Haight Ashbury neighborhood. It was down the street from the Zam Zam Room, a bar made famous decades earlier for its Martinis. Daniel Hyatt held court as the bar

manager and became widely respected by his peers for his work. "Daniel had creativity to the max," says Scott Baird. "He made it look so easy. It was so easy for him to make incredible drinks and do weird stuff. He was the dude for me in that regard." Hyatt built the cocktail program around classics and slight variations of them, for which he reserved half of the menu. The other part of the menu featured house originals where he could showcase his creativity, like his use of savory flavors. His goal was to make balanced, simple, accessible drinks that people found interesting. The bar also boasted a big selection of American craft spirits, which set it apart from other places. Thomas Waugh, who had worked as Marco Dionysos' barback at the Starlight Room, also bartended there. Waugh went on to work at Death & Co. in New York after doing a bartender exchange program. He, too, is now known for his excellent drinks.

Rye also opened in 2006 on Geary Street in the Tenderloin, right around the corner from Bourbon & Branch. It was the brainchild of Greg Lindgren and John Gasparini, who had opened 15 Romolo together. Phil Mauro was on the opening staff and worked there in addition to Foreign Cinema. Carlos Yturria later joined the team. Yturria had worked with Lindgren and his wife, Shelly, a renowned sommelier, at A16, a restaurant owned by the couple, and was excited about the opportunity to create a new cocktail bar. Leading up to Rye, Yturria had started entering cocktail competitions, which allowed him to showcase his creativity and network with other bar professionals. Rye began hosting its own competitions, which was a draw for other bartenders and elevated the bar's status. It attracted Marco Dionysos, who worked there for two years after leaving Michael Mina's Clock Bar (which also opened in 2008), and Mauro went on to become the bar manager.

Duggan McDonnell, who had left Frisson, had long set his sights on opening a bar. He opened Cantina, a bar with high ceilings and an open layout in Union Square. He opened to much fanfare, as he had gained a loyal group of people who were following his career. He focused on pisco, the Peruvian brandy, and featured this in many of his drinks. He also incorporated seasonal produce, earning himself a reputation as a bar chef. Cantina became an important part of San Francisco's cocktail landscape because it balanced history with its culinary take on drinks. It had the feel of a neighborhood bar in the middle of downtown San Francisco and felt like an oasis for people who needed an escape from the city's buzz. McDonnell sold Cantina in 2016 to Kevin Dietrich, a bartender who had worked previously in New York at the famed speakeasy-style bar

Tiki décor. *Photo by Nando Alvarez-Perez and Vaughan Glidden. Courtesy of Pagan Idol.*

Tiki wall décor. *Photo by Nando Alvarez-Perez and Vaughan Glidden. Courtesy of Pagan Idol.*

PDT. Though the bar's name changed to PCH (for Pacific Cocktail Haven) under Dietrich, he is keeping Cantina's spirit alive by featuring unique flavor combinations like miso butter and salted pistachio and using a pineapple as an international sign for hospitality.

Tiki aficionado Martin Cate opened Forbidden Island across the bay in Alameda in April 2006. Cate channeled his passion for tiki into his own bar. He worked with California-based tiki artists to ensure the space was historically accurate and fit into the canon of tiki design. "There is a very clearly defined aesthetic of tiki," says Cate. "There is a fairly rigid construct based on historical design and design elements and building materials. Tiki brings together Polynesian arts, it brings together nautical, brings together these natural materials." To match the look and feel, Cate put together an authentic drink menu with high-quality ingredients. "We were making high-quality orgeat and coconut cream, and we were making several of the syrups in house. Nobody was doing that in the tiki world," Cate says. Cate, who had become part of the larger cocktail community, was taking cues from his bartender friends, as well as traditional tiki methods. "The weird thing that had to happen, and started with me at Forbidden Island, was this notion of tiki being craft again. This idea of, 'They're taking a page from the craft. It's marrying the craft cocktail,' is true, but it's also just kind of going back to the origins. It's going back to the 1930s and '40s when you would have been juicing fruit fresh. In that way, as tiki historian Jeff Berry has noted, tiki was always craft originally," Cate explains. The bar was received with open arms and immediately won acclaim. It became one of the most popular bars in the Bay Area, signaling that people had not stopped loving tiki. This bar laid the groundwork for the modern tiki boom in San Francisco, with Cate at the helm.

The Cocktail Boom

These bars, in addition to Bourbon & Branch and the bars that came before them, created the new landscape of Bay Area cocktail culture. The work that Thad Vogler, Julio Bermejo, Paul Harrington and Marco Dionysos did, along with the crop of people immediately following, created a new model for bars. Together, their collective work set the tone for new bars that aspired to the same level of acclaim.

The year 2008 ushered in the growth of bars around the city. Many of these projects involved bartenders who were part of the pre-2006 revival. They took what they learned from their experiences and made the industry stronger.

One such example of this was Beretta, an Italian restaurant specializing in thin crust pizza in the Mission. It opened on the corner of Twenty-Third and Valencia Streets in a humble brick building close to City College. Adriano Paganini, who had made a small fortune by selling his chain of fast casual Pomodoro restaurants, financed the project. He hired Thad Vogler to set up the program. "Beretta was super instructive in terms of doing a really good bar once I was unchecked," says Vogler. "Adriano was really helpful because he's not very egotistical. He's a restaurateur who wants to know how is this financially viable. I remember meeting with him and being like, 'What are we going to do for Beretta?' He had me write this two-paragraph thing to be sure that we understood exactly. He's really good at refining a concept and removing arrogance from it. He and I are kind of polar opposites; I make it very complicated, and he is like, 'This is a pizza place that does cocktails.' He doesn't have a lot to prove, so he was really helpful."

Vogler was gearing up for the project while he was working at Bourbon & Branch. The bartenders there were significantly burned out after two years of nonstop grinding in the Tenderloin. So when they heard Vogler was working on something new, they jumped at the opportunity. "Over the period of a month, everyone asked me if I wanted to have coffee," Vogler says. "I remember Todd [Smith] said, 'Do you want to go get a coffee?' [Jon] Santer said, 'Do you want to get a coffee?' Eric Johnson said, 'Do you want to get a coffee?' Ryan [Fitzgerald] wanted to talk. I never thought that they would have any interest in coming to work for me, but they all said, 'Hey, can we come?'"

Beretta's opening team resembled something like Bourbon & Branch version 2.0. "We had a crazy opening team at Beretta," says Santer. "It

Left: Erik Adkins; *Right*: Thad Vogler. *Photos by Jon Santer.*

was Thad and Todd and Ryan and Eric Johnson and myself, all of whom came from Bourbon & Branch. It felt like we were hired guns. We were at the top of our game at that time. There was nobody better on the West Coast." It proved to be a much easier environment for them all. Santer took his usual position in the service well, cranking out drinks as fast as he could. Whenever Vogler saw him getting stressed, he would pull him aside and say, "This is cocktails and pizza." After that, Santer learned to enjoy it. "It was leaving the grinder that was Bourbon & Branch and having fun at Beretta," he says.

The team helped create one of San Francisco's best cocktail menus to date. "The crew we brought over had so much experience," says Fitzgerald. "You learn really fast how to fix a cocktail when you have Jon Santer and Todd Smith and Thad Vogler and Eric Johnson all sitting around talking about it." In fact, some of the drinks are still on the menu today and are often ordered at other bars around town. One such was the Single Village Fix, which included mezcal. "I loved that drink. I thought it was incredible," says Fitzgerald. (The cocktail even helped Beretta win the Bar Brawl competition a few years later at Tales of the Cocktail when Fitzgerald was representing the bar.) After Vogler's contract was up, he left to open Camino in Oakland and eventually his first bar, Bar Agricole. Fitzgerald slowly assumed the position of bar manager. "Bit by bit, I started having more responsibility," he says. He helped keep the cocktail program strong while furthering his education about spirits. "It gave me the opportunity to interface with brands more and bring in new products," he says. Beretta is still one of the most popular cocktail bars in San Francisco.

Thad Vogler at Bar
Agricole in San
Francisco. *Photo by
Jon Santer.*

The same year, in 2008, Bloodhound opened in the South of Market
(SoMa) area in San Francisco. Dylan O'Brien, who was an industry
veteran by the age of thirty, decided to take the next step in his career
and open his own bar. He had left his job managing César a few years
earlier to work for a startup that specialized in managing private wine
collections, but he longed to be back in bars. When he heard about the
sale of a seedy dive bar in a part of town where there were no other decent
cocktail bars, he jumped at the opportunity. His business partners owned
Double Dutch, a bar in the Mission, and together they turned the bar into
a warm, wooden cocktail haven, complete with taxidermied animals. He
had more experience with cocktails than his business partners. "I did a
lot of staff training on spirits, mechanics and techniques. The back bar
design was kind of an improvement upon the bar design at Double Dutch.
Everything was designed around efficiency. When you go behind the bar
there, it's an absolute pleasure to make drinks because everything is right
at hand. You don't have to move, so there's not a lot of wasted motion," he
says. Bloodhound became a cocktail oasis in a food desert. "Bloodhound
is a machine," O'Brien says. "It is working. It is great." It attracted tech
workers, denizens of SoMa and industry friends. It's a place where up-
and-coming bartenders can come to learn more about the craft or where
industry veterans can pull a couple of shifts to earn consistent cash. Though
O'Brien sold his shares in the business after he opened Prizefighter, he is
the reason that the bar became beloved.

Now, cocktails needed to have good ingredients, whether that was
quality spirits, fresh juice, seasonal fruit and herbs or house-made syrups
and tinctures. They needed to be consistent, so components of drinks
were now being measured. They needed to include a variety of spirit

categories, not just vodka. Ice needed to be good so dilution would be consistent. And in many cases, they needed to be thoughtful, either invoking history or local agriculture. Bars were no longer allowed to be an afterthought if they hoped to garner a good reputation. The immediate popularity of these bars also illustrated that there was a place for them in a market saturated with farm-to-table restaurants. They created space for different types of bars all over the Bay Area. There was now a place for bars that focused on history and classic drinks, farm bars that were organized around agriculture and culinary bars that showcased fresh produce. And as these bars, and their lead bartenders, were getting more and more press, San Francisco's reputation was creeping up to that of New York. San Francisco was now a cocktail destination.

Highball of whiskey and soda (see appendix for recipe). *Photo by Nando Alvarez-Perez and Vaughan Glidden. Courtesy of Ramen Shop and Umami Mart.*

SHAKEN AND STIRRED

THE WEST COAST COCKTAIL

T he term "West Coast cocktail" brings a number of things to mind, all of which relate to craft. Whether it conjures an orchard of ripening pears waiting to meet their fate in a bottle of eau de vie, a mixture of berries fermenting into a shrub to preserve the flavors of summer or herbs and spices infusing a high-proof spirit to become bitters, it's all connected to seasonality. While it's true this is a large part of the West Coast cocktail's identity, there is also a strong relationship to history. A number of classic cocktails were created in the Bay Area—like the Martinez, the Mai Tai and the Pisco Punch—while many of the region's most popular drinks today are variations of classics. In fact, I've had some of my favorite versions of Negronis, Old Fashioneds and Manhattans at bars around the Bay.

Perhaps the reason why West Coast cocktails are more frequently associated with colorful, juicy drinks than stronger, spirituous libations is because of the way they are discussed in cocktail writing. In the mid-aughts, as people began opting for Gimlets over gamay wine, media coverage of drink culture was ramping up. West Coast cocktails—which were largely represented by the Bay Area—were depicted in a particular way. Stirred drinks got less attention than shaken concoctions, and the connection to history often wasn't mentioned. The tricky part was that many drink trends in the Bay Area transcended these stereotypes while not completely defying them. Back in 2008, Gary Regan wrote an article for the *San Francisco Chronicle* entitled "The Cocktail Divide: West Coast and East Coast Cocktail Cultures Couldn't Be More Different, Right?" Regan

set up the idea that San Franciscans were more interested in organic ingredients than history and tradition like their New York counterparts. Regan explored this so-called divide as he unpacked the origins of this idea, attempting to blur the lines between coastal styles in the process. "Regan set it up as East Coast versus West Coast. East Coast is all about classic revival and being spirit forward, and the West Coast is throw it in a glass and muddle it. You can definitely find strong examples of both, but he is absolutely to blame for the generalization when he was writing for the *San Francisco Chronicle*," says Neyah White.

In fact, the first few lines of the article read:

> *Like true sons and daughters of the hippie generation, the young bartenders of San Francisco tend toward organic cocktails filled with homegrown this and hand-fed that. Their creative juices are sweetened only with pure agave nectar. Back east in New York City, the progeny of Wall Streeters hold forth from behind the ivy-covered bars of the Big Apple. They seem to enjoy reinventing drinks that have been with us for a century at the very least, adding a drop of this, a dash of that, changing, perhaps, just one ingredient to bring the drink into the 21st century.*

Though the piece wasn't intended to reinforce these ideas, it did just that. Regan included quotes from bartenders that reiterated the impact that restaurant culture had on San Francisco bars but didn't address how this had shaped Bay Area cocktail culture. Bezuidenhout referenced the influence Alice Waters had on the industry's interest in fresh ingredients. Toby Maloney, then a New York–based bartender, called his locale more traditional and conservative, while San Francisco was more experimental. Thomas Waugh commented on the quality of citrus on the West Coast, having insight from his time working on both coasts. Phil Ward, a New Yorker who had come to San Francisco for the bartenders' exchange program, posited that Bay Area residents care more about where ingredients come from, while New Yorkers care more about history. There are several other quotes that essentially posit the same ideas, including the notion that New York bartenders handle egg whites and ice better than San Franciscans. It included recipes from these bartenders that were intended to complicate the narrative, including White's Grilled Peach Old Fashioned.

From this came the repercussion of unintended consequences. "I will say that there weren't a whole lot of 'throw it in a glass and muddle it' bars in New York in 2007, but there certainly were plenty of people doing hardcore

classics in San Francisco," White says. "It was an incredible piece, actually, but it was unfair. It certainly helped my career, but it set up this false sort of angst. After that, there was this supposed rivalry between West Coast and East Coast. When you get down to it, though, it couldn't be further from the truth. We loved each other. We still do." White feels this generalization has started to fade, signifying an end to the imagined rivalry. "Fortunately, that's all gone away with other cities taking the forefront and with so much cross-pollination with people moving all over the place," says White.

Regan's intentions for the article may have been good, but other writers grabbed onto this idea and perpetuated it in their work. The idea that West Coast cocktails were shaken (or muddled), not stirred, became a widespread notion that resurfaced in 2013 when Jordan MacKay published an article addressing the topic in the web-based drink magazine *PUNCH*. The piece was called "What Has Become of the West Coast Cocktail? The Rise of the 'West Coast Style' of Cocktail, What Drove It, Who Embraced It, and Just What's Happened to It." MacKay doesn't dispute that there is a style associated with San Francisco drinks, evident in the very first line. "When I first started bartending the notion of the 'West Coast style' of cocktail was in full bloom," he wrote. He worked at Cantina, Duggan McDonnell's bar, and says of this, "We juiced. We shook the shit out of our drinks." He wrote that styles of drinks common in different regions have "long been a matter of fascination in the drinks industry," comparing it to terroir in wine. McDonnell, whom he quotes, corroborates his arguments.

MacKay used famous pre-Prohibition-era bartenders, tiki history and the relationship between the kitchen and the bar to illustrate his points about the fruity nature of the West Coast cocktail. He identified David Nepove, Marco Dionysos, Scott Beattie and the Tommy's Margarita as examples of modern bartenders who preferred muddlers to bar spoons. He argued that bartenders grew tired of scouring farmers' markets for new ingredients, juicing to order and spending money on fresh produce. He also says, "As their devotion to the culinary dimmed in intensity, San Francisco bartenders became more infatuated with classic spirituous cocktails and the speakeasy—channeling bars of New York." This unintentionally delegitimized the progress that Bay Area bartenders had made over the past twenty years. Thus, Regan's article lived on, reducing the Bay Area to a singular dimension of bartenders obsessed with seasonality. The arguments in these pieces are thin, though it is undeniable that there was a heavy influence of the culinary world on the bar scene.

In reality, the strength of the West Coast cocktail's identity is not dwindling because of fatigue. It is not dwindling because San Franciscans wanted to

Selection of bitters. *Photo by Nando Alvarez-Perez and Vaughan Glidden.*

adopt New York bar culture. Its identity is blurring because the philosophies and techniques pioneered on the West Coast are being widely used around the country, including New York, as White had said. In the Bay Area, it's impossible to point to one person and say, "That's who is responsible for introducing fresh juice to the bar." In New York, it is commonly known that it was Dale DeGroff who made fresh juice standard protocol. People don't juice to order anymore because demand is too high and it would be inefficient. Bars now have their own prep people who squeeze juice and make syrups, much like kitchens.

Moscow Mule (see appendix for recipe). *Photo by Nando Alvarez-Perez and Vaughan Glidden.*

Moreover, history has always been central to cocktails in California. In fact, it may actually have been the first place to bring classic cocktails to the masses, thanks to Paul Harrington and Marco Dionysos. "San Francisco has always been a cocktail town," says Dominic Venegas. Many things have changed over the past thirty years, but people have not grown tired of cocktails in the Bay Area, or food and wine, for that matter. There are more people choosing bartending as a career every day all across the country. There's now an entire body of literature that allows newcomers, and even enthusiasts, to get just as excited as Harrington and Dionysos did back in the 1990s.

Harrington didn't need to ask how to make a Manhattan; he always knew. At Absinthe, Dionysos used the menu as an outlet for his fascination with history. It was a choice they made because they cared, not because they were emulating another person or a city's culture. This began before the days of the Internet, before a time when the phrase "bar community" was a normal part of the lexicon. They weren't trying to keep up with older, more seasoned bartenders who had been around long enough to see cocktails lose steam when the Industrial Revolution rolled around. This is why the Bay Area deserves more credit for its contributions. As White says, cities do not need to be portrayed as rivals.

COMMUNITY

The Bay Area cocktail revival is about more than styles of drinks, history, the region's relationship to classic cocktails or the influence of food and agriculture. Out of this renaissance emerged a new community of people. In the Bay Area, the bonds of the cocktail community are tight and friendships enduring. People are eager to teach one another and learn from their peers. It is one of the most supportive communities in the country. Bar owners here are interested in opening neighborhood spots with solid drinks and friendly service. In other words, they want their bars to be spaces where everyone feels welcome. I encountered countless examples of the strength of the cocktail community throughout my interviews, making me realize just how special the Bay Area is.

When I first sat down with Jennifer Colliau to discuss our oral history interview, it was immediately clear that she is steeped in the community and it is a place where she feels she belongs. Colliau, who is intelligent, well read and process oriented, loves to discuss recipes and drink history. While not everyone is interested in talking about these aspects of cocktail culture, she felt welcome to have these conversations with Erik Adkins when she was working for him at the Slanted Door. "Erik and I could talk about the minutia of drinks more than anyone else really had the patience for," she says. "I've been in a lot of situations where I feel very uncomfortable about being different. I'm intense and detail oriented, and the amount of research I do is my life and my livelihood. I will fall asleep with books on me. It's what makes me feel like I have integrity. I feel like I'm finally in a place, in a community, in an industry that respects that and is cool with me being different. So talking with Erik, he welcomes me getting really intense and talking about every detail."

She also told me that she never would have been able to launch her pre-Prohibition-era ingredient company, Small Hand Foods, without the support of her peers. Colliau started working on her orgeat recipe while she was bartending at the Slanted Door, which was encouraged by Adkins. In fact, he used it in their house Mai Tai. Colliau was just starting to hit her stride in the industry but didn't yet know that many people. "The United States Bartenders' Guild hadn't started at this point, and no one knew me, really," she says. "But when people would come into the bar who Erik knew, he would make them a Mai Tai. They would be like, 'Oh my god, this is awesome.' Erik would be like, 'Hey, Jen, come over here. Meet this person.' I got to know all of these people, like Brooke Arthur, who was managing

Range. After trying my orgeat, she was immediately like, 'I want this for my bar. I think that is awesome.' She wasn't shitty or cagey or asked me how to make it. She was just like, 'This is awesome.' That was it." This support allowed Colliau to grow her hobby into a side hustle and then into a full-fledged business as other friends started to carry it at their bars. "People here are awesome. They are just so supportive. I don't know how to describe it better than that," she says.

Another example of the bonhomie that illustrates the strength of the Bay Area bar community happened during a time of crisis. In 2008, Brooke Arthur was badly injured when her apartment caught fire in early January. She was hospitalized for weeks, which was followed by months of recovery. "It was a lot of cognitive and physical therapy. I had to relearn everything," she says. Her friends in the bar industry immediately rallied around her. Not only was there an outpouring of concern for her health, but her circle knew that her hospital bills were mounting and she had no income from being out of work.

They decided to help her by raising money to ease the financial burden of her expenses. "There was a huge benefit put together for me by Duggan McDonnell and Eric Carlson and my family. I think it was really the first time in San Francisco that something bad had happened to one of our own. Range had a fund going for me the entire time I was gone, and they matched the amount of money that was raised," she says. McDonnell, Carlson and her network made sure that people came to the fundraiser in droves. They wrangled people outside the industry, too, who didn't know her personally. "For years, after I got better, I had people coming up to me being like, 'You're Brooke Arthur? I went to your benefit!'" she says. Her benefit ended up bringing in over $50,000. Moreover, Range made sure she had a job when she was well enough to return to work. "Everyone came to see me when I was back at Range," she remembers. "It was a really strong bar family. There were so many people that called me and checked in on me. It made my relationships stronger."

Banding together for Arthur's recovery is emblematic of what the Bay Area is best at: showing up. It's something that people here have always done for one another in times of crisis and in peace. The effort that people make when they do something as simple as visit a fellow bartender at work creates a sense of unity. "I've always felt a kinship and camaraderie," says Dylan O'Brien, owner of Prizefighter. "I've always had lots of friends because you go to other people's bars and restaurants. After work, you'd end up at the same bar and trade stories. I think in the East Bay, and San Francisco as well, there has always been a pretty strong community of people working in hospitality. It's

always been really supportive, and people want one another to succeed so they can go to good places and have places they can recommend to their guests."

People in the community have always been willing to share information with one another to help others succeed. "The community in San Francisco, at least in my lifetime, was the strongest community in the country, and probably in the world. It was the first community when this whole cocktailing thing happened that really came together and shared ideas," says Jon Santer, who owns Prizefighter with Dylan O'Brien. Much of this culture grew out of the early conversations that Marco Dionysos, Jacques Bezuidenhout, David Nepove, Todd Smith and Santer were having in North Beach, resulting in the formation of San Francisco's chapter of the United States Bartenders' Guild. "We all got together and agreed to care about this thing and talk about it. We went to each other's places and egged each other on and did the secret handshakes. It was a real thing. We all actually liked each other, and it was a real community," says Santer. Ryan Fitzgerald, who now owns ABV with Todd Smith and Erik Reichborn-Kjennerud, says of this moment, "I think back to that first USBG meeting, and I can't help but think that San Francisco has been a leader in the cocktail world."

Ultimately, these connections allowed bartenders to feel like they had chosen a legitimate career that they didn't need to justify. "I remember the questions about being a bartender in Oklahoma," says Jonny Raglin, partner in Comstock Saloon. "It was always a steppingstone. Like, 'I'm doing this to get through college and then I'm going to do something big,' or 'I'm just doing this to save some money.' I just wanted to be in a place where there was a culture that would support bartenders their whole lives and not question them." When he moved to San Francisco, he joined the community and built a stable career. No one judged his career choices here. Those who have helped shape modern cocktail culture want their colleagues, new and old, to feel like they have a serious job. "I want people to feel a sense of pride and self-worth for being a bartender," says Erik Adkins, bar director for the Slanted Door Group.

Cocktail culture in the Bay Area was more of a movement than an era. It challenged bartenders to be more thoughtful about their approach to their jobs, whether through taking a culinary approach to drinks, thinking about technique, incorporating history or sharing knowledge with friends and guests. They raised the bar for their peers around the country, and out of dedication to their craft, they created a culture in which community is central. "I'd like it to be remembered as a time when we changed the way that America drinks," concludes Santer.

POSTSCRIPT

When I first began interviewing people involved in the West Coast cocktail renaissance, I was immediately struck by how seriously they took my work. I didn't need to explain why I thought this project was important—they already knew. They had been working in the industry much longer than I, and they understood the significance of cocktail history in the Bay Area. They knew their contribution and those of their predecessors, mentors and friends had helped create one of the strongest communities in the world. Their interest in history, understanding of quality ingredients, dedication to choosing products with integrity over those that are poorly made, willingness to share ideas and educate their peers, devotion to creativity and innovation, attention to technique and hospitality and desire to engender a supportive network of people who care are all aspects of the Bay Area that have made it one of the most important in cocktail history.

Cocktails are about much more than what is in the glass. They are about the intersection between craft, agriculture, history, community and culture. The cocktail revival reveals the story of American society. Cocktails may be fun, but bars are where history is shaped. The stories of those who run the places where people find happiness, friendship and comfort are valuable and can teach us much more than the recipe to our favorite drink—they can help us deepen our understanding of the world in which we live.

RECIPES

Tommy's Margarita
2 ounces 100 percent blue agave tequila
1 ounce fresh lime juice
½ ounce agave syrup

Shake. Pour into a rocks glass. Garnish with a lime.

Pisco Sour
2 ounces pisco
1 ounce fresh lime juice
¾ egg white
½ ounce simple syrup

Assemble the ingredients in a tin without ice and shake for 10 seconds, allowing the egg white to froth. Add ice to the tin; shake until the tin is cold. Strain into a coupe glass. Add a few drops of Angostura bitters on top.

Gin + Tonic

2 ounces gin (the author prefers St. George Botanivore)
Top with tonic water (the author prefers Fever Tree tonic)

Serve on ice in a rocks glass. Garnish with a lime. The author prefers to spruce it up with a few dashes of celery bitters.

Moscow Mule

1 ounce vodka
1 ounce fresh lime juice

Top with ginger beer. Serve on the rocks in a mug or rocks glass. Garnish with a lime.

Jasmine

***From Paul Harrington's book* The Drinks Bible for the 21st Century**

1 ½ ounces gin
¾ ounce fresh lemon juice
¼ ounce Cointreau
¼ ounce Campari

Shake. Strain into a coupe glass. Garnish with a lemon peel.

Martinez

2 ounces Old Tom gin
1 ounce sweet vermouth
¼ (or bar spoon) maraschino liqueur
3 dashes of Angostura bitters

Stir. Strain into a coupe glass. Garnish with a cherry.

Highball
Courtesy of Chris Lane, Ramen Shop
1 ¼ ounces Japanese whiskey

Add ice and stir whiskey for a few seconds to dilute and chill. Top with seltzer water (Lane prefers Q Seltzer) and stir gently to integrate. Add a bit more ice to fill glass. Garnish with a small expressed lemon peel.

Fogcutter
A Trader Vic's favorite, recipe adapted by Smuggler's Cove
2 ounces blended lightly aged rum
1 ½ ounces fresh lemon juice
1 ½ ounces fresh orange juice
1 ounce pisco
½ ounce gin
½ ounce orgeat
½ ounce olorosso sherry

Shake all ingredients except for the olorosso sherry with crushed ice. Pour into tiki mug or Fogcutter glass. Float the olorosso sherry on top.

Pisco Punch
From Duggan McDonnell's book Drinking the Devil's Acre
2 ounces pisco
1 ounce fresh lime juice
1 ounce pineapple cordial
½ ounce Lillet Rouge

Shake. Strain into a coupe glass. Garnish with an orange peel.

CLASSICS AND RIFFS

The Classic: Daiquiri
2 ounces white rum
1 ounce fresh lime juice
½ ounce simple syrup

Shake. Strain into a coupe glass. Garnish with a lime.

The Riff: Hemingway Daiquiri
From Paul Harrington's book The Drinks Bible for the 21st Century
1 ½ ounces light rum
¾ ounce fresh lime juice
¼ ounce fresh grapefruit juice
¼ ounce maraschino liqueur

Shake. Strain into a coupe glass. Garnish with a grapefruit peel.

The Riff: Agricole Daiquiri
Courtesy of John Fragola, Beretta
1 ½ ounces blanc agricole rum
1 ounce lime juice
½ ounce Jamaican Pot Still Rum
½ ounce Martinique Petite Cane Syrup

Shake. Strain into a coupe glass. Garnish with a lime.

The Classic: Mai Tai
A Trader Vic's original, recipe adapted by Smuggler's Cove
2 ounces blended aged rum
¾ ounce fresh lime juice
½ ounce Pierre Ferrand dry curacao
¼ ounce orgeat
¼ ounce rich simple syrup (made with a 1:1 water to sugar ratio, as opposed to
regular simple, which is a 2:1 water to sugar ratio)

Shake with crushed ice. Pour into tiki mug.

The Riff: Mai Tai Float
Courtesy of Daniel Parks, Pagan Idol
1½ ounces Denizen Reserve rum
1 ounce fresh lime juice
¾ ounce Combier orange curacao
½ ounce orgeat
½ ounce Santa Teresa 1796 rum
½ ounce orgeat
¼ ounce fassionola gold syrup

Shake all ingredients with crushed ice and pour into a double rocks glass. Add ½ ounce of Pagan Idol's house float (4 parts Skipper Demerara rum, 1 part Pedro Ximenez olorosso sherry, 1 part Cynar 70, 1 part Tempis Fugit Crème de Cacao and an orange peel). Garnish with a mint spring, a pineapple spear and an umbrella.

The Classic: Manhattan
2 ounces bourbon
1 ounce sweet vermouth
3 dashes Angostura bitters

Stir. Strain into a coupe glass. Garnish with a cherry.

The Riff: Nero Manhattan
Courtesy of Hamlet
2 ounces rye whiskey
½ ounce sweet vermouth
½ ounce Nardini amaro
3 dashes orange bitters

Stir. Strain. Garnish with an orange peel.

The Classic: Negroni
1 ounce gin
1 ounce sweet vermouth
1 ounce Campari

Stir. Strain onto ice in a rocks glass. Garnish with an orange peel.

The Riff: Bruto Negroni
A favorite of the author's
1 ½ ounces St. George Botanivore gin
1 ounce sweet vermouth
1 ounce St. George Bruto aperitif

Stir. Strain onto ice in a rocks glass. Garnish with an orange peel.

The Classic: Mojito
From Paul Harrington's book The Drinks Bible for the 21st Century
Build in a 16-ounce glass.
8 to 10 mint sprigs
½ ounce simple syrup
1 lime cut in quarters
Squeeze lime, put quarters in glass and muddle lightly.
2 ounces light rum
Add crushed ice. Use barspoon to mix together. Top with soda water.
Garnish with mint sprig.

The Riff: Kumquat Mojito
A drink from David Nepove
Build in a 16-ounce glass.
8 to 10 mint sprigs
½ ounce simple syrup
Half of a lime
Squeeze lime and put wedges into glass.
3 halved kumquats
Muddle lightly.
2 ounces light rum
Add crushed ice. Use barspoon to mix together. Top with soda water.
Garnish with mint sprig.

The Riff: Strawberry Mojito
Build in a 16-ounce glass.
½ ounce simple syrup
Half of a lime
Squeeze lime and put wedges into glass.
2 quartered strawberries
Muddle lightly.
2 ounces light rum
Add crushed ice. Use barspoon to mix together. Top with soda water.
Garnish with strawberry.

INTERVIEWS

Erik Adkins. St. George Spirits, Alameda, CA. October 2016.
Kayoko Akabori and Yoko Kumano. Umami Mart, Oakland, CA. May 2016.
Brooke Arthur. Phone, October 2016.
Scott Baird. Trick Dog, San Francisco. February 2017.
Julio Bermejo. Tommy's Mexican Restaurant, San Francisco, CA. 2015.
Jacques Bezuidenhout. Irish Bank, San Francisco, CA. September 2016.
Lou Bustamante. Hard Water, San Francisco, CA. August 2016.
Martin Cate. Smuggler's Cove, San Francisco, CA. August and November 2016.
Jennifer Colliau. San Francisco, CA. 2014.
Marcovaldo Dionysos. Lolo, San Francisco, CA. July 2016.
Christine Farren. San Francisco, CA. June 2016.
Ryan Fitzgerald. ABV, San Francisco, CA. July 2016.
Paul Harrington. Phone. October 2016.
Jessica Maria. Hotsy Totsy, Albany, CA. October 2016.
Phil Mauro. San Francisco, CA. January 2017.
David Nepove. San Francisco, CA. August 2016.
Dylan O'Brien. St. George Spirits, Alameda, CA. October 2016.
Jonny Raglin. Comstock, San Francisco, CA. July 2016.
Bryan Ranere. San Francisco, CA. December 2016.
Jörg Rupf. St. George Spirits, Alameda, CA. November 2014.
Celia Sack. Ominivore Books, San Francisco, CA. June 2016.

Jon Santer. Oakland, CA. July 2016.

Rhachel Shaw. Berkeley, CA. 2014.

Claire Sprouse. San Francisco, CA. 2014.

Dominic Venegas. Phone. February 2017.

Thad Vogler. Trou Normand, San Francisco, CA. 2015.

Neyah White. Phone. July 2016.

Lance Winters. St. George Spirits, Alameda, CA. 2015.

David Wondrich. Brooklyn, NY. 2015.

Carlos Yturria. San Francisco, CA. July 2016.

INDEX

ABOUT THE AUTHOR

S hanna Farrell is an oral historian with the Oral History Center at the University of California–Berkeley. She holds an MA in interdisciplinary studies from New York University and an MA in oral history from Columbia University. She lives in San Francisco, California.